SOLANO COMMUNITY COLLEGE

S0-CAR-209

ANDREW WYETH

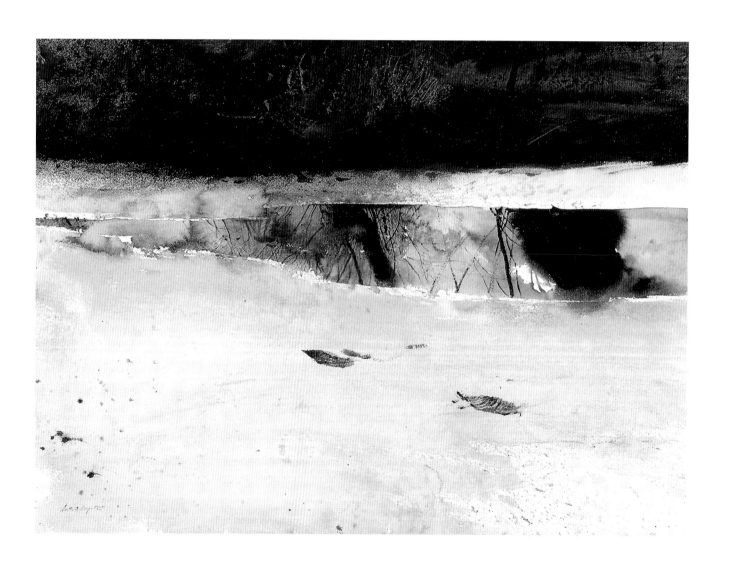

UNKNOWN TERRAIN:
The Landscapes of
ANDREW WYETH

Beth Venn and Adam D. Weinberg

with a contribution by Michael Kammen

WHITNEY MUSEUM OF AMERICAN ART, NEW YORK
DISTRIBUTED BY HARRY N. ABRAMS, INC., NEW YORK

This book was published on the occasion of the exhibition

"UNKNOWN TERRAIN: THE LANDSCAPES OF ANDREW WYETH,"

organized by the Whitney Museum of American Art, May 28–August 30, 1998

This exhibition is supported by Robert W. Wilson,
The Horace W. Goldsmith Foundation, and the Exhibition Associates of the Whitney Museum.

Research for the exhibition and publication was supported by income from an endowment
established by Henry and Elaine Kaufman, The Lauder Foundation, Mrs. William A. Marsteller, The Andrew W. Mellon Foundation, Mrs. Donald A. Petrie,
Primerica Foundation, Samuel and May Rudin Foundation, Inc., The Simon Foundation, and Nancy Brown Wellin.

Cover image:
Andrew Wyeth, COMING STORM, 1938

Frontispiece:
Andrew Wyeth, ICE POOL, 1969

The history of twentieth-century American art is constructed in several ways. First, it is a simple record of the work that has influenced the development of what we have come to call an "American" style. We might define this as an aesthetic method and approach consistent with the notion that this century would be known—in form and substance—as the American century. The second construction of American twentieth-century art traces the forces at work in our culture and upon the social fabric, as the nation transformed itself into a dominant global power. It is the third construction, however, that provides the framework we use here: that the history of American art can be recounted as an aggregate of pure individualism and complete aesthetic freedom. This is the method that enables us to document thousands of remarkable individuals whose vision and achievements underscore the central quality of what we think of as American art.

Among these artists are those whose work refuses to fit the neat categories of American modernity set forth by the critical and academic establishment. Lacking a definitive place in constructed history, such artists are often relegated to the oddball pile or, worse, are simply written off. But it's not that simple. Certain artists resurface by gently insisting that they be reckoned with on their own terms—that their art be contextualized by nothing other than its own parochial history. And this, fortunately, is what keeps the history of art interesting, far less predictable and, in an ornery sort of way, very American indeed.

The great realist painter Andrew Wyeth is by nearly any measure

8 considered an American icon. He is also a prime example of the artist working happily and comfortably outside

of mainstream critical and curatorial circles. At eighty years of age, drawing and painting all day, every day, Wyeth works in the splendid isolation afforded by his studios in the hills of rural Chadds Ford, Pennsylvania, or on the craggy shore of Port Clyde, Maine. This physical isolation is a reflection of Wyeth's aesthetic sensibility, an extension of his flinty determination to be unmoved by a century that has changed every other thing around him.

Wyeth finds inspiration in his own history, from Howard Pyle through his father N.C. Wyeth and his son Jamie. Pyle and N.C. Wyeth were old-fashioned journeyman artists, not schooled or market-groomed. Their contained and simplified view of the art world has enabled Andrew to keep a steady focus on the things that matter to him. We see direct evidence of this focus in the visually elegant and psychologically piercing works that have poured out of his studio for over fifty years. In some ways, Wyeth has paid dearly for his lack of engagement in the stylistic developments of postwar American art. But he does not feel in any way deprived. In fact, it seems that his outsider's perch has given him the necessary intellectual and psychic space to pursue his own vision.

Yet for all this self-willed isolation, Wyeth found himself tethered to his time. As Whitney curator Adam Weinberg points out, Wyeth evolved a spare, nearly abstract style with a subtle yet clear relation to prevailing attitudes about pictorial representation. In the temperas, watercolors, and drybrushes selected for this unique survey, Weinberg and co-curator Beth Venn reveal that Wyeth's genius lies not only in his mastery of traditional technique and reductive thematic focus, but as well in the incorporation of the dynamics of abstraction. Such dynamics control the look of Wyeth's art no less than does his far more famous subject matter.

The Whitney Museum is grateful to curators Venn and Weinberg for their deep commitment to bringing Wyeth's art to New York once again, and for their intelligent, perceptive, and loving analysis of it in their contributions to this catalogue. Art historian Michael Kammen's insightful essay also makes an essential contribution by helping us understand Wyeth's distinctly American qualities.

On behalf of the Trustees of the Museum, I would like to express our deep appreciation to the collectors, both public and private, who have agreed to lend to this exhibition. We also owe a great debt of gratitude to Robert W. Wilson, The Horace W. Goldsmith Foundation, and the Exhibition Associates of the Whitney Museum for their generous funding support.

We are truly indebted to the artist's wife, Betsy Wyeth, whose support and encouragement have been crucial to the success of this project. We are also extremely grateful to Nicholas Wyeth, who has worked tirelessly on behalf of the exhibition, and whose advice and counsel were of inestimable value. In Chadds Ford, Mary Adam Landa gave unstintingly of her time, and provided the Museum's curators with full and unfettered access to the meticulously maintained Wyeth collection, archives, and records. Richard Meryman, Wyeth's longtime friend and biographer, gave generously of his time, his own records and files, and shared his deep understanding of Wyeth's art and life. But finally, it was the artist himself whose trust and openness made this exhibition not only possible, but a complete delight for all involved. On behalf of the Museum, I thank him for his gracious forbearance, his unbounded enthusiasm, and his powerful enduring spirit.

10 DAVID A. ROSS
Director
Whitney Museum of American Art

Although Andrew Wyeth is one of America's best-known artists, his renown is based on a relatively small portion of his work. Of the thousands of watercolors, drybrushes, and temperas he has produced in his sixty-year career, probably fewer than a thousand have been exhibited or reproduced. Viewing and studying the lesser-known works required the assistance of several individuals, most importantly, Mary Adam Landa, curator of the Wyeth Collection, who spared no effort in making the collection accessible and in tracking down works—many made more than a half-century ago and long unseen. The labor she put into this exhibition and catalogue was herculean. For this and her generous support of our unorthodox approach to the artist's work, we are deeply grateful. Landa's assistant, Deb Sneddon, helped us navigate the Wyeth database and prepare works for our numerous whirlwind research visits. Lauren Smith, conservation intern for the Wyeth Collection, was of great assistance in assessing the condition of many of the works in the exhibition. We also owe thanks to Frank Fowler for providing insurance valuation for Wyeth's works.

No other staff can mobilize itself like that of the Whitney Museum when it comes to producing an exhibition and book on relatively short notice. Shamim Momin, research assistant, handled every detail of the project with great skill and aplomb. Her tireless research, diplomatic handling of loans, and deft coordination of the publication and installation made her an indispensable member of the curatorial team. Naomi Urabe, research assistant, was also extremely helpful with initial research, as was Adrienne Bratis, intern.

The Whitney Museum publications department—Mary DelMonico, head, Nerissa Dominguez, production manager, Sheila Schwartz, editor, Dale Tucker, copy editor, and Christina Grillo, assistant—together with Anita Duquette, manager of rights and reproductions, and the book's designer Lorraine Wild, did an extraordinary job of structuring a cogent and beautiful volume from a somewhat unwieldy mass of material. Although many books have been published on Wyeth during his long career, the design of this one is distinct, fresh, and gives substance to our aspirations. Christy Putnam and Yvette Lee of the Museum's exhibitions department have been astute and exacting in their coordination of the financial and technical aspects of the exhibition.

Two other individuals, who became virtual members of the Whitney staff during this project deserve great credit. Our co-author, Michael Kammen wrote an essay that complements our own efforts and reveals a new direction for the reconsideration of Wyeth's work and career. And Janet Cross, the exhibition's designer, has devised an elegant and harmonious space which articulates a clear but interesting path through Wyeth's "Unknown Terrain."

We are especially indebted to the lenders, whose generosity and support have been critical to the exhibition's success. Both private collectors and museums have played an integral role, entrusting their much-loved pictures to our care (a full list of lenders appears on p. 221). Shuji Takahashi, curator of the Aichi Prefectural Museum, Nagoya, Japan, who served as liaison for Japanese loans, deserves special notice for his work as a superb negotiator.

The idea to organize a Wyeth exhibition originated with the Whitney Museum's director, David A. Ross, in discussion with Richard Meryman, Wyeth's longtime friend and biographer.

12

They encouraged us to present an exhibition that would highlight Wyeth's finest accomplishments and simultaneously chart a new course in a reappraisal of the artist's work. Their enthusiasm and support have enabled us to realize this product.

Most of all, we wish to thank the Wyeths. Nicholas Wyeth has been a great friend in this effort, offering his guidance and expertise at key moments during the organization of the exhibition. Andrew and Betsy have been extraordinarily generous in every way. Their willingness to give two curators previously unknown to them complete access to all of the works in their collection was an act of great trust. They fully endorsed the idea of the exhibition, but magnanimously wanted it to be "our exhibition," uninfluenced by their outlook or conceptions. We are deeply grateful to them for their warmth, insights, and friendship. We hope this exhibition will be as surprising and engaging to them as the curating has been for us.

BETH VENN
Associate Curator, Permanent Collection
ADAM D. WEINBERG
Curator, Permanent Collection

Adam D. Weinberg

TERRA INCOGNITA:
Redefining Wyeth's World

Few artists have made the blood of so many critics boil as Andrew Wyeth. It's curious that one of the most traditional painters of the century raises more ire than many of the radical artists of the avant-garde. In 1967, in an *Arts Magazine* column called "Critique," Lawrence Alloway wrote about "The Other Andy," comparing Wyeth not to Andy Warhol, one of the few other twentieth-century artists to achieve the controversial status of an American pop icon, but to Walter Keane, the kitsch painter of saucer-eyed children.[1] "He is, as much as Walter Keane is, a reflex-jabbing image-maker, but for a classier trade. Wyeth's virtuosity is an essential part of his appeal: the ostentatious quirks of technique which attain stereoscopic effects make him a kind of Al Hirt of the drybrush."[2] Such venom reached new levels in 1987 with the presentation of "Andrew Wyeth: The Helga Pictures" at the National Gallery in Washington, which was lambasted by critics from both right and left: Hilton Kramer complained, "This is the kind of art that gives the realist aesthetic a bad name"; Peter Schjeldahl, echoing the perennial criticism of the artist, pronounced, "Wyeth isn't exactly a painter. He is a gifted illustrator for reproduction, which improves his dull originals...."[3]

As recently as a year ago, reviewing a new biography of Wyeth, Michael Kimmelman encapsulated the prevailing take of urban establishment art critics: Wyeth's "contempt for modernism equals the contempt modernists have had for him."[4] Wyeth has been excoriated for his sentimentality, his narrative approach, his rural subject matter, his purposeful naïveté, his commitment to realism, his appeal to the middle class and, as Alloway observed, even his extraordinary technical abilities.

The hyperbole on the other side has been no less strident. Wyeth has been loved by critics from small-town publications, and by the public at large, for all the reasons that other critics hate him. He has been celebrated as a champion of realism, as the most popular American artist, as

15

the master of humanist art, and as the heir to the Hudson River School, Winslow Homer, and the great tradition of homegrown Yankee painting. He has been honored by three presidents: Kennedy, Johnson, and Nixon (the accolades by the latter two also a reason for many to reject his work), been on the cover of *Time* magazine, and received countless honors.[5] One critic hailed him as "beloved by the silent majority."[6] Another exclaimed, "in today's scrambled-egg school of Art, Wyeth stands out as a wild-eyed radical. For the people he paints wear their noses in the usual place, and the weathered barns and bare-limbed trees in his starkly simple landscapes are more real than reality."[7]

While a number of critics have respected Wyeth's accomplishments and have tried to appraise the strengths and weaknesses of his art without prejudice—Elaine de Kooning, Lincoln Kirstein, Thomas Hess, and especially Brian O'Doherty and Wanda Corn—it is still extremely difficult to assess Wyeth's art in a polarized critical climate. (Although few recent appraisals of Wyeth's art have been as damning as Kimmelman's, the discussion is still tainted by excessive praise or vitriole, judging from the recent response to Richard Meryman's Wyeth biography.)[8] Over the last several decades, some art historians and critics have tried to reconcile Wyeth's work with mainstream post-World War II modernist art, in particular abstract painting, in the hopes of locating a middle ground between realism and abstraction. In 1953, Aline Louchheim, in an article entitled "Wyeth—Conservative Avant-Gardist," maintained that many advocates of the avant-garde champion his work "because they see that what appears to be literal transcription is instead a highly selective means toward an intense, subjective and wholly twentieth-century expression." Details in Wyeth's work, she noted, "become almost abstract vehicles and symbols for expression of mood and emotion."[9]

Twenty years later, Wanda Corn drew instructive comparisons between Wyeth's painting and abstract painters as well as contemporaneous photographers: "Indeed many of his loose and gestural sketches bear strong resemblance to some of the abstract work of these artists [Kline, de Kooning and Pollock]."[10] Thomas W. Styron, in the 1984 exhibition catalogue *Andrew Wyeth: A Trojan Horse Modernist*, saw Wyeth "welcomed into the fortress of the *bourgeoisie* because they derive a sense of valorization from his traditional style and pastoral settings. But, from within that functional framework of familiarity and fastidiousness the revolutionary/evolutionary message of modernism invades and transforms."[11] In this context, Styron acknowledges the meaninglessness of describing Wyeth as anti-modern, yet persists in trying to define him as a closet modernist. Over the years, Wyeth himself has repeatedly tried to sidestep the issue by maintaining a different criterion of judgment. Of the Abstract Expressionists, he said, "I like their vitality...I don't care whether a painting is representational or purely abstract in its form....Either it's good or it's bad."[12] He admitted, however, that he found looking at a whole exhibition of Abstract Expressionist paintings boring. Several years later, he declared somewhat disingenuously, "I am not a realist at all. The subject is unimportant....I agree with Pollock and Kline and de Kooning that there must be no laws: there must be complete freedom." But, he concluded, yielding to his own conflicted feelings, "they lack the object."[13]

Wyeth's own ambivalence about abstraction reveals a fundamental problem in the present terms of critical discourse. It becomes more and more apparent that trying to position Wyeth in relation to antithetical poles of realism and abstraction is ultimately a losing proposition. Such terms do, of course, enable us to see the origin of his work in American realism and Regionalism of the 1920s as well as the influence of modernist painting and photography on his art. However, Wyeth's work should not be a

shuttlecock batted to and fro between dualistic positions. In the postmodern era, one doesn't have to be either a realist or an abstract painter. The distinction between the two is largely artificial, based as much on ideology as style. What Linda Nochlin observed about nineteenth-century realism applies equally to Wyeth: "The commonplace notion that Realism is a 'styleless' or transparent style, a mere simulacrum or mirror image of visual reality, is another barrier to its understanding....Realism was no more a mere mirror of reality than any other style...."[14] In short, realism is no more real than abstraction. Keeping in mind that both realism and abstraction are culturally determined, we can avoid irreconcilable either/or positions. By looking at Wyeth's art simply as a reflection of warring aesthetic ideologies, we miss its complexity, its mix of ideology, technical skill, style, and personal psychology. We also miss seeing this art as a legitimate response to contemporary life, the kind of response for which other realist artists have been acclaimed rather than assailed as anachronisms. A decade ago, John Updike thought it curious to see Wyeth excluded from a range of critically acceptable realisms in later twentieth-century art. "In the heyday of abstract expressionism, the scorn [for Wyeth's work] was simple gallery politics; but resistance to Wyeth remains curiously stiff in an art world that has no trouble making room for photorealists like Richard Estes and Philip Pearlstein and graduates of commercial art like Wayne Thibault [sic], Andy Warhol, and for that matter, Edward Hopper."[15]

Wyeth's landscape painting—broadly defined and in all media, with special attention to his largely overlooked watercolors—offers an opportunity to reintegrate his work as a whole into the fabric of twentieth-century art. Because of Wyeth's penchant for narrative and the public's and media's love of a "story," a critical focus on anecdote has often replaced more serious considerations of his work. By examining Wyeth's landscapes one

can, to some degree, view his work without narrative impediments, without the legends that surround them, the legends that many love and others detest. Not surprisingly, dozens of exhibitions and books have focused on Wyeth's characters and their lives, in particular Christina Olson, Karl Kuerner, and Helga Testorf. Although their centrality in Wyeth's paintings is undeniable, their place in his oeuvre has been overplayed. Christina Olson, for example, may have been one of Wyeth's key subjects for twenty-five years, but landscape as an independent subject or as a dominant element has prevailed in his art for six decades. Wyeth's landscapes cut across time, place, genre, and technique; landscape, in fact, underlies all his work. As we shall see, even in those "mature" paintings that include figures, and in the portraits themselves, what concerns Wyeth is the connection of people to the land itself.

It is with the exuberant landscape watercolors of Maine, begun in 1937, that Wyeth made his debut as a serious artist and achieved national recognition. Although figures frequently appear in these works, they are usually summarily and minutely painted and serve primarily compositional purposes. In Wyeth's earliest temperas, begun in the late 1930s, the subject remained landscape. In the next decade, important landscape paintings were far more numerous and significant than portraits and figure subjects. Some works, such as ROAD CUT (1940; Fig. 55), DIL HUEY FARM (1941; Figs. 14, 54), and PENNSYLVANIA LANDSCAPE (1942; Fig. 69), are strictly landscapes, while in others—among them PUBLIC SALE (1943; Fig. 66), in the Social Realist tradition, and WINTER FIELDS (1942; Figs. 22, 65), a *memento mori*—landscape is, despite the narrative element, *the* protagonist in the drama. In PUBLIC SALE, the point of the painting is the loss of the land; in WINTER FIELDS, though the crow appears to be the central subject, the land itself is the focus, as the title reveals.

The significance of the landscape in Andrew Wyeth's art is evident in two of his most important and best-known paintings—neither of which are simply landscapes. WINTER, 1946 (1946; Fig. 58) is an allegorical work painted shortly after the tragic death of Wyeth's father, who was killed when his car stalled on the railroad tracks as a train approached—a tale now an essential part of the Wyeth legend. The ostensible subject of the tempera is the running boy. However, the hill that seems about to engulf him is as much the subject, both in terms of its scale and its bulging presence. The oft-repeated story is that Wyeth regretted never having painted his father. "The hill finally became a portrait of him."[16] The landscape in CHRISTINA'S WORLD (1948; Figs. 1, 61), by far Wyeth's most famous work, similarly dwarfs the sprawled, angular figure of Christina. As Wyeth said in a 1961 interview, "I think perhaps it would have been possible to have painted just that field and have you *sense* Christina without her being there."[17] In another comment about this work, he compared the figure of Christina to a beached lobster.[18] A comparison between CHRISTINA'S WORLD and one of Wyeth's 1940 seascape watercolors (Figs. 2, 50) is not so far-fetched, both compositionally and metaphorically. Christina perched precariously on the hill is, like the lobster, a prisoner of her environment.

In a much later tempera, ABOVE THE NARROWS (1960; Fig. 95), the title itself suggests the union of subject and setting, as it puns on the leanness of the figure and the water formation. In this tempera, the bare legs are the same hue as the grass from which they sprout, while the misty white of the shirt unites the upper portion of the figure with the sky. Seen from the back, like Christina, the man is not so much observing the land as part of it, frail and susceptible to the elements. This is further emphasized by the relatively sharp focus of the background, which compositionally connects the figure to the far shore nearly as much as the ground on which he stands.

20

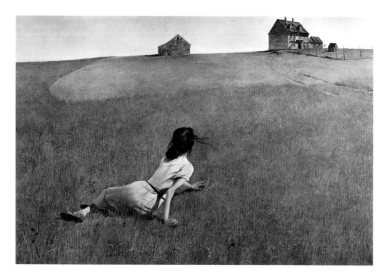

1. CHRISTINA'S WORLD, 1948

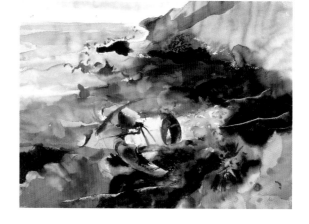

2. UNTITLED, 1940

The figure in, and integrally of, the landscape is especially evident in some of Wyeth's watercolors, such as CAROLYN WYETH (1963; Fig. 110) and UNTITLED (ARMY SURPLUS STUDY) (1966; Fig. 104). Here the seated and camouflaged figures are continuous in color and form with the land itself. In the former, the fairly well-defined head and shoulders atop the lightly penciled torso read almost as a rock, a bush, or other natural element. In the wetly painted untitled watercolor, the lanky limbed figure has the character of a fallen branch.

It can also be argued that many of Wyeth's "typical" portraits are treated as topography and lend themselves to topographical verbal description. ANNA CHRISTINA (1967; Fig. 3): craggy, worn facial features, thick mass of hair, protruding upper body (reminiscent of Wyeth's characteristic hillsides), dappled, leathery, foliage-patterned dress—and all painted in somber earthtones as if infused with the land Anna Christina inhabited. The land is in Anna Christina as much as she, Anna Christina, is in the land in CHRISTINA'S WORLD. In this sense, even Wyeth's "pure," unpeopled landscapes have a human presence. It is no accident that Wyeth confined himself and his work almost exclusively to two locales: rugged coastal Maine—the area around Cushing—and the rolling, verdant hills around Chadds Ford, Pennsylvania. As he has recounted time and again, his family history and personal experience in each place inflected his feeling for the land itself. "I couldn't get any of this feeling without a very strong connection for a place....It's that I was born here, lived here—things have meaning for me."[19] And indeed, Wyeth has associations and memories connected with many of his landscape paintings, particularly the temperas. About SNOW FLURRIES (1953; Figs. 4, 74), for example, with its understated subject and reductive composition, he said: "I spent almost a year on this tempera because I was fascinated by the motion of those cloud shadows on that hill near

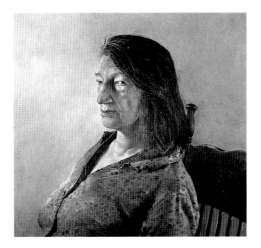

3. ANNA CHRISTINA, 1967
Tempera on panel, 23½ x 21½ (59.7 x 54.6)
Partial gift and private collection; courtesy Museum of Fine Arts, Boston

Kuerner's farm and by what that hill meant to me. I've walked that hill a hundred times, a thousand times ever since I was a small child...."[20]

Do such stories and the narrative cues in the paintings change the viewer's perception of the work? Perhaps to a public uncomfortable with minimal subject matter they provide a welcome guide. For others, Wyeth's comments, the titles of the paintings—which often suggest anecdote— as well as the symbolic elements in the works are intrusions that tend to lead to specific, predictable readings. To state the obvious, the more one knows, the more restricted the experience of the painting. What is striking about a number of Wyeth's landscapes is how the clues are diminished as well as balanced with abstract form. Temperas such as HOFFMAN'S SLOUGH (1947; Fig. 59), SNOW FLURRIES (1953), RIVER COVE (1958; Figs. 5, 91), LIME BANKS (1962; Fig. 96), and THIN ICE (1969), with their compact, tightly cropped natural elements, forward-tipping picture planes, high or nonexistent horizon lines and restricted earthtone palettes, only allude to human presence. There are, for example, in HOFFMAN'S SLOUGH, two minute buildings and the trace of a dirt road; SNOW FLURRIES has two fence posts in the foreground, a couple of faint posts in the middle- and backgrounds, and the slight ruts of a path leading to the horizon. While lacking evidence of people, the clam shells and bird tracks in RIVER COVE hint at narrative. Works such as these, among Wyeth's finest, allow for ambiguous, multiple readings. Other works, such as BROWN SWISS (1957; Fig. 82), THE SWEEP (1967; Fig. 125), or PENTECOST (1989; Fig. 162), prominently feature the man-made and hence suggest narratives. Whose house is depicted in BROWN SWISS? What is the meaning of the single oar resting on the wall in THE SWEEP? In PENTECOST, how do the fishing nets strung from poles relate to the title? BROWN SWISS and THE SWEEP also have metaphorically evocative titles. Yet the very spareness of the man-made elements in these works

22

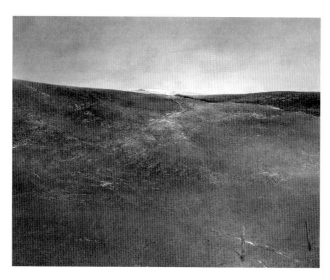

4. SNOW FLURRIES, 1953

puts a brake on anecdotal musings. They are connotative elements which conjure associations rather than, as in some Wyeth paintings, denotative signs proposing literal readings. Each component is more a self-sufficient subject of the composition than a passage in a tale.

Many modernist artists who were Wyeth's contemporaries, from Barnett Newman to Mark Rothko to Franz Kline, resisted the encroachment of the verbal on the visual, the anecdotal on the universal, the particular on the mythic. For such artists, representation no less than narrative was anathema. As Barnett Newman wrote in 1948, "We do not need the obsolete props of an outmoded and antiquated legend. We are creating images whose reality is self-evident and which are devoid of the props and crutches that evoke associations with outmoded images, both sublime and beautiful. We are freeing ourselves of the impediments of memory, association, nostalgia, legend, myth, or what have you, that have been the devices of Western European painting."[21] Such comments by one of the most articulate and outspoken high modernists slammed the door in Wyeth's face. Newman's position was perhaps the most extreme. Rothko, although not interested in creating images with associative subjects, did think of "pictures as dramas; the shapes in the pictures are the performers."[22] And Franz Kline had no difficulty with works that suggested observed reality. "There are forms that are figurative to me, and if they develop into a figurative image it's all right if they do."[23] Here Kline seems to be making the same kind of accommodation to representation as Wyeth often did to abstraction. What these quotes suggest is that abstraction was no more monolithic—and no more abstract—than realism. Each artist had a different take. Today, with the demise of the modernist prohibition on narrative, Wyeth's paintings need not be measured against the dogma of purist abstraction but on their own terms.

For Wyeth, the artist must acknowledge the real object, "the fleeting

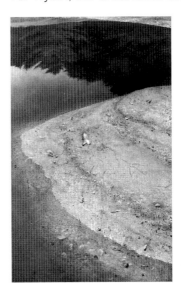

5. RIVER COVE, 1958

character of the thing,"[24] and provide an entrée for the viewer not only through representation, but through specific clues. He uses realism as a lure for the spectator, yet recognizes the danger of overloading his paintings with incidental information: "My pictures are apt to be overfed and the objects overexpressed."[25] "I think the great weakness in most of my work is subject matter. There's too much of it."[26] Moreover, the increase in subject matter is often connected to medium, for the tempera and drybrush, both slow media, apparently encourage Wyeth to build up subject matter as well as brushstrokes.

In many of his thousands of watercolors, Wyeth avoids the trap of the incidental. His freer watercolors in particular reveal a tendency to loosen the hold of prescriptive narrative—of technical detail and anecdotal subject matter—a loosening that often has a beneficial effect on the image. The effect arises not because the work becomes more abstract, but because it permits a broader interpretation and experience. In a work such as UNTITLED (1963; Fig. 112), for example, Wyeth has applied broad swaths of sienna, ocher, and dark green to suggest a fore-, middle-, and background. The elbow-shaped form with a hint of leaves in the upper left and a few details in the dark green evoke a landscape. But it is the bold strokes themselves that resolutely capture the look and idea of landscape. The spontaneity of Wyeth's watercolors sometimes short-circuits his rational thinking process ("let it out before you begin to think"), exposing what he called his "wild side," his real nature—"messiness."[27]

Although Wyeth often escapes storytelling through the loosely applied pigment of his sketchlike works, he has also produced many detailed paintings which must be judged a success. Despite varying amounts of visual data many such works do not succumb to the anecdotal. In a so-called "finished work" such as EDGE OF THE FIELD (1955; Fig. 84), we still feel what Wyeth calls "the white heat of

excitement" so typical of the more freely brushed sketches.[28] However, while the incised lines and detailed flourishes of the brush encroach on this abstract energy to denote the edge of a field, the overall power and unity of the work remains undiminished by incident. Or, an even more extreme example: the tightly painted drybrush COLD SPRING (1988; Fig. 153), with seemingly endless, almost photographic detail as well as particular information, from the scaliness of the bark to the mirrorlike reflection of the water. The amount of incident here is visually overwhelming. The result of this sensory inundation is a work that is nearly as open-ended as the wildest sketches. Thus, while the most rapidly produced abstract watercolors often provide less anecdotal information, they are not categorically more successful. By "upgrading" the best of Wyeth's gestural works and not downgrading the best of the detailed works, one realizes that Wyeth is simultaneously working in at least two, or even multiple, equally strong realist modes.[29]

Wyeth's meticulously conceived watercolors and temperas have received much attention. It is the freely brushed works that have been most ignored. To reconsider these latter, which to some extent Wyeth and others have dismissed as sketches, studies, or unfinished compositions, one must take into account the enormous amount of time he devoted to watercolors over the last six decades. There are hundreds, as against roughly two hundred extant temperas. He and his wife, Betsy, saved them, carefully catalogued them and, on rare occasions, exhibited them. (Almost one-third of the works in the present exhibition are watercolors not previously exhibited.) Although Wyeth was trained in an academic tradition that distinguished the study from the completed work, later twentieth-century artists often found the distinction irrelevant. Even Winslow Homer, an artist Wyeth greatly admires, recognized that the difference between a sketch and finished work was simply a difference of scale rather than effort. He once told a student, "Now

6. Winslow Homer
HIGH CLIFF, COAST OF MAINE, 1894
Oil on canvas, 30⅛ x 38¼ (76.5 x 97.2)
National Museum of American Art, Smithsonian Institution,
Washington, D.C.; Gift of William T. Evans

those are nice little sketches...but, you know, if you used larger brushes and a canvas, with exactly the same effort you would have had a picture instead of a sketch" (Fig. 6).[30]

In the spirit of Homer—and of our own postmodernist era—it seems inappropriate to continue to treat Wyeth's temperas, watercolor studies for temperas, finished independent watercolor compositions, and unfinished, "sketchy" watercolors as if they were produced by different artists, or by the same artist at different levels of professional dedication. A similar late twentieth-century mentality enables us to rethink another misconception about Wyeth: that his work is stylistically static—and hence "unmodern." "Wyeth clinched his manner over 30 years ago and there's been little stylistic change since," commented Thomas Hess in 1976.[31] Katherine Kuh found it "impossible to pinpoint any chronological stylistic development in his work."[32] And Hilton Kramer thought of Wyeth's art as a standard product "in which everything is reduced to a formula."[33] Even Wanda Corn, one of the artist's champions, gave a one-dimensional character to the work, describing it as an art "of continuity and permanence in face of the instabilities and uncertainties of modern life."[34] Others have claimed that the oeuvre is photographic and, implicitly, without style altogether.[35]

Wyeth's work is more accurately seen as an oscillation of styles and subjects, of periodic progressions, digressions, and recapitulations. A style or subject introduced in one period may be reintroduced numerous times throughout his oeuvre. This may be Wyeth's response to what he perceives as the restrictiveness of style: "Styles are a terrible thing to an artist."[36] Unlike Edward Hopper, who arrived at his hallmark style in the mid-1920s and virtually never wavered throughout his career, Wyeth is restless and circuitous. His multiple approaches are every bit a reflection of his roguish, loquacious manner as Hopper's single-minded approach was a reflection of his laconic sobriety.

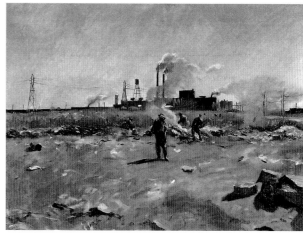

7. WILMINGTON DUMP, 1936
Oil on canvas, 31½ x 42½ (80 x 108)
Collection of Andrew and Betsy Wyeth

A new model of Wyeth's work needs to be devised that reveals this restlessness rather than an alleged stasis, that reveals the artist's complex permutations of realist styles and subjects. Moreover, this reconsideration must acknowledge that the importance of a work is not necessarily proportionate to the amount of time Wyeth invested in it. There is also a different transactional relationship to be considered, one in which the flow of ideas is not simply from watercolor to tempera, with drybrush serving as an intermediate combination of the two.

An exhaustive examination of Wyeth's multirealist patterns, even within the seemingly limited—though enormous—territory of his landscape painting, is not within the scope of this essay. It is, however, possible to convey the character and periodicity of several of Wyeth's realist modes: topographical realism, magic realism, classical realism, and expressionist realism. Some of these styles recur with great frequency, others less often, and all are introduced in the first decade of Wyeth's work: in his relatively small body of oil paintings (numbering less than a hundred); his very first, almost completely unknown temperas (of which there are a dozen or so); and the previously mentioned, semi-abstract watercolors that he produced in Maine in the late 1930s and early 1940s.

In 1934, Wyeth painted a small oil called WILMINGTON DUMP (1936; Fig. 7), a work that seems to be aberrant in his career. While deriving from a Social Realist sensibility like that of Thomas Hart Benton or John Steuart Curry, there is nothing homespun or sentimental about this painting. Unlike other more picturesque, Social Realist oils Wyeth made at the time, such as BILL LOPER WITH BIG TREE TRUNK (1934; Fig. 8), this Depression-era scene matter-of-factly depicts a group of people scavenging through rubbish with one central, though faceless, figure who seems to confront us. The pickers are set

27

8. BILL LOPER WITH BIG TREE TRUNK, 1934
Oil on canvas, 31½ x 42½ (80 x 108)
Collection of Andrew and Betsy Wyeth

against a trash-strewn landscape and a horizon articulated by high-tension power lines and smokestacks atop industrial buildings and water towers. WILMINGTON DUMP exposes a contemporary landscape marred by the inclusion of unsightly, man-made features. In this period of Wyeth's art, it is a one-of-a-kind subject that parallels some of the industrial landscapes by contemporaneous photographers such as Walker Evans.

Topographical realism does not resurface in Wyeth's work until around 1981, when he paints OLIVER'S CAP (Fig. 154). Like WILMINGTON DUMP, this painting of contemporary subject matter is unusual for Wyeth, with its banal blue-and-white fringed umbrella, the electric wires leading to the house, the rusty propane tank, and the section of white-lined blacktop and three wire-strewn highway posts in the background. Besides the occasional television antennae and telephone poles that make minor appearances in some of his watercolors and drybrushes, this is the first landscape that admits contemporary topographic features in decades. A succession of works in the mid-1980s, however, continues this brief flirtation with present-day subject matter, most notably the tempera RING ROAD (1985; Fig. 158), with the automobile sign post, and the watercolors SUNDAY TIMES (1987), featuring a crumpled newspaper with color advertise-ments, and COUNTRY WEDDING (1970; Fig. 124), focusing on a modern-day party tent. Conspicuously, all but the last—including OLIVER'S CAP—announce their dissonance with the natural landscape through a single vivid, almost garishly colored element. In these paintings of the 1980s, Wyeth is experimenting as much with palette as with content.

In 1943, Wyeth was included in the landmark exhibition "American Realists and Magic Realists," organized by Dorothy C. Miller and Alfred H. Barr, Jr., at The Museum of Modern Art. The exhibition was devoted to artists who used "*sharp focus and precise representation*, whether the

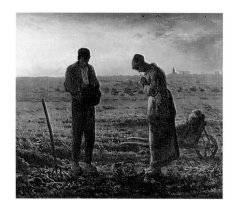

9. Jean-François Millet
THE ANGELUS, 1857-59
Oil on canvas, 21⅞ x 21⅝ (55.6 x 55)
Musée D'Orsay, Paris

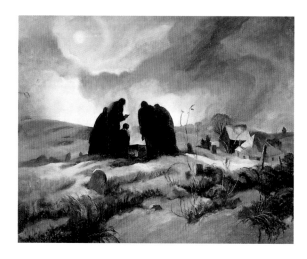

10. BURIAL AT ARCHIES, 1933
Oil on canvas, 31½ x 39½ (80 x 100.3)
Collection of Andrew and Betsy Wyeth

subject has been observed in the outer world—*realism*, or contrived by the imagination—*magic realism*."[37] From the selection of eight works by Wyeth, it can be surmised that the curators thought of Wyeth more as a realist than as a magic realist. Strictly speaking, according to Barr's definition of magic realism as a realistic technique applied to "make plausible...dreamlike or fantastic visions," all Wyeth's works were realist.[38] However, given the radical, dramatic, low point of view in WINTER FIELDS (1942; Figs. 22, 65) and FROG HUNTERS (1941) and the fantastic scale of the crow in the former and the skunk cabbages in the latter, these works should be considered as much magic realist as realist.

This exaggerated, magic realist style is first recognizable in Wyeth's early oils. In ROBERT HOWORTH SLEDDING (1935; Fig. 11), the large swirl of smoke in the background seems about to envelop the boy in its frosty, tornadolike funnel. In a radically different painting, BURIAL AT ARCHIES (1933; Fig. 10), reminiscent of Jean-François Millet's THE ANGELUS (1857-59; Fig. 9), stooped and darkly silhouetted figures gather in a graveyard under an ashen, nebulous sky; the effect is resolutely otherworldly. The magic realist sensibility remained a powerful undercurrent in Wyeth's oeuvre. Not only is it manifest in the 1940s in landscapes such as SUMMER FRESHET (1942; Fig. 70), with its fish-eye distortions and molten shimmering stream, and CHRISTMAS MORNING (1944; Fig. 12), where the landscape becomes a shroud and a single star twinkles symbolically in a crepuscular sky, it also persists in SOARING (1950; Fig. 60). Here the toylike house is seen fantastically from a bird's-eye view, while in SPRING (1978) the figure of a man partially buried in snow appears to melt into a hillside. Watercolors such as COUNTRY WEDDING (1970; Fig. 124) and WINTER COAT (1985; Fig. 155) also have surreal overtones. The eerie white party tent in a field shows no trace of a wedding, while the wrapped form of the boat has a mysterious, feckless air.

29

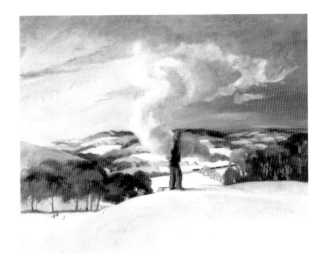

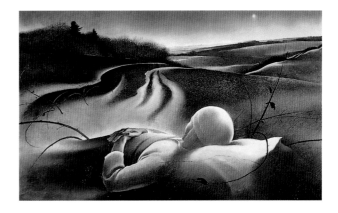

11. ROBERT HOWORTH SLEDDING, 1934
Oil on canvas, 32 x 40 (81.3 x 101.6)
Collection of Andrew and Betsy Wyeth

12. CHRISTMAS MORNING, 1944
Tempera on panel, 23¾ x 38¾ (60.3 x 98.4)
The Regis Collection, Minneapolis

Wyeth's classical realism, with affinities to mid-nineteenth-century Luminist painting, is one of his most recurrent stylistic tendencies. It is characterized by a crisp, photographic technique, emphasis on order, linearity, quietude, and frequent use of the reflective properties of water. At most times in his career, Wyeth believed this realist style to be his goal. As he wrote in 1943 and ritually repeated in variable form, "My aim is to escape from the medium with which I work. To leave no residue of technical mannerisms to stand between my expression and the observer. To seek freedom through significant form and design rather than through the diversion of so-called free and accidental brush handling."[39] These words, as Barbara Novak has pointed out, could have been written by Luminist painter Fitz Hugh Lane, an artist whose work Wyeth came to know and admire in the 1940s.[40]

Wyeth's preoccupation with the contemplative, classically composed landscape began with his initial experiments in tempera in the late 1930s. MORNING LOBSTERMAN (1939; Figs. 13, 20) is structured in a manner similar to Luminist paintings, horizontal bands—land, water, land, sky—and a rather small figure to suggest the human place in the grand scheme of nature. Despite noticeable, fluid brushstrokes with occasional small flourishes of pigment, the work is controlled and ordered. The prevailing concern here is with transcriptive detail and the inner light that seems to emanate from the water and sky. The serenity and extreme horizontality in this painting recur in works such as DIL HUEY FARM (1941; Figs. 14, 54). Here, however, a tree is positioned front and center, partly blocking visual access to the farm, which is the ostensible subject. The small farm buildings indicate the humble position of humankind in relation to the land. By this time, Wyeth had perfected his tempera technique to minimize the visual trace of the artist's hand. BROWN SWISS (1957; Fig. 82), despite its radical asymmetry, is a definitive statement of Wyeth's classical style,

30

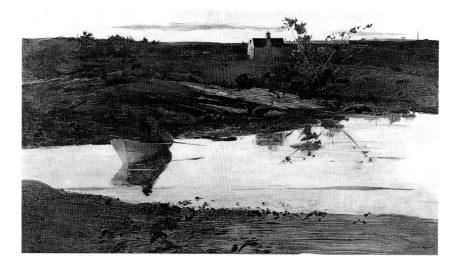

13. MORNING LOBSTERMAN, 1939
Tempera on panel, 27 x 47 ⅞ (68.6 x 121.6)
Collection of Andrew and Betsy Wyeth

a style whose virtuosity of technique is just as evident in FAR FROM NEEDHAM (1966; Fig. 121). Although lacking the horizontality, atmospheric light, and water of other classical works, FAR FROM NEEDHAM, with its nearly square format and bold, frontal composition, conveys a classical spirit through simplicity, clarity, and crisp hyperrealism.

Aspects of Wyeth's classical realism also appear in the looser watercolor medium. While the emphasis on precise detail is to some degree lacking in ICE POOL (1969; Fig. 119), the stillness of the mesmerizing reflection, the carefully ordered, stratified structure, and the delicately balanced composition are emblematic of many Wyeth watercolors. A relatively recent work, the meticulously detailed, luminously limned drybrush COLD SPRING of 1988 (Fig. 153), although vertical in format, is reminiscent of the 1941 DIL HUEY FARM. But rather than evince an unchanging style over four decades, COLD SPRING represents an elaboration of a subject Wyeth introduced in the early forties and has been examining with great variety and inventiveness ever since—a single tree cropped top and bottom, virtually bisecting the frame and tightly sandwiched between the picture plane and background. In comparison to UNTITLED (Study for BROWN SWISS) (1957; Fig. 83), with its soft, dusky background, and the simpler composition of SYCAMORE (1982; Fig. 144), COLD SPRING is almost baroque in its emphatic details, radically cropped reflection, and dramatic angle of the hill, which provides a somewhat vertiginous counterpoint to the leaning tree.

Wyeth's expressionist realism is the least acknowledged and exhibited aspect of his work, perhaps because its seemingly crude and often defiant lack of refinement is not what his audience wants or expects. Perhaps, too critics can more easily pigeonhole and demonize Wyeth by ignoring the existence of such expressionist works. These images have their roots in the fluid, energetically

31

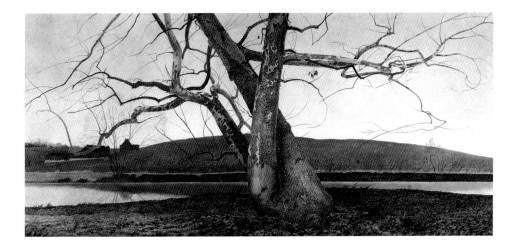

14. DIL HUEY FARM, 1941

applied, saturated hues of his early watercolors, those made between 1937 and 1942. During the last half cen-

tury, Wyeth's expressionism has taken varying stylistic forms, from broad sweeps of thinly applied pigment,

UNTITLED (1955; Figs. 15, 115) and BACKWATER (STUDY) (1982; Figs. 31, 139), to almost cinematic, compositionally

segmented layers of scumbled pigment in UNTITLED (RIVER COVE STUDY) (1958; Fig. 86) and DISTANT

THUNDER STUDY (1961; Figs. 16, 101), to the rough, crusty surface of UNTITLED (QUARTER MOON STUDY) (1984;

Figs. 17, 151) and the opaque, shadowy, virtually impastoed quality of UNTITLED (1979; Fig. 138).

Unlike work in his other realistic styles, Wyeth's expressionist paintings

only exist in one medium, watercolor, but there are perhaps more than a thousand of them throughout the oeuvre.

Some are studies for other works, but most are untitled sketches that remain in Wyeth's collection. Often

exhibiting great violence and anger, they seem to renounce Wyeth's technical facility, as if he were unlearning

the habits of his craft. It is easy to dismiss these works as incomplete, muddled missteps. But in fact they

disclose how the artist's sensibility, skill, and knowledge of materials are so highly developed that he can cap-

ture intangible essences: the character of light (and darkness), the effect of space and, most of all, the

sensation of the land itself.

UNTITLED (1950; Fig. 92) is a watercolor that bears the nuances of Wyeth's

first watercolors in the blue and magenta washes of the distant sea and in the smudges of color that play

across the largely monochromatic, rough-hewn boulders. The image is compositionally suggestive of Winslow

Homer's late, tightly cropped, coastal paintings and of the raw energy of Marin's watercolors of the Maine

shore (Fig. 18). However, Wyeth's harshly and heavily painted watercolor with incised lines, while generalized and

32 rather abstract, is not, like Marin's, structured by a Cubist schema. Wyeth's rocks rely more on observation;

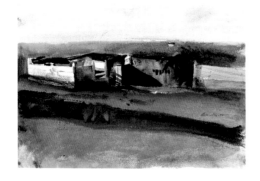
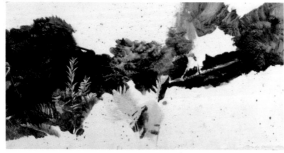
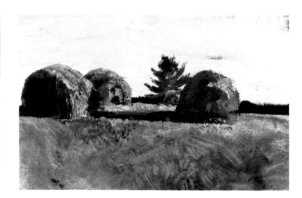

15. UNTITLED, 1955 16. DISTANT THUNDER STUDY, 1961 17. UNTITLED (QUARTER MOON STUDY), 1984

they retain their "rockness," while Marin's have to be analyzed to yield the idea of rocks and water as much as the substance.

In UNTITLED (1978; Figs. 19, 23, 137), made almost thirty years later, the paint is so dark and wildly applied that at first glance it appears to lack any recognizable features. But once accustomed to the swirling darkness of the pigments, you begin to follow the trail of coarse, white paper into a sylvan background. It's astonishing how Wyeth rapidly created a sense of light on a snow-covered, plant-lined path—or perhaps reflections on a stream—and the feeling of a deep, complex, space. A moodiness and visceral sense of the land amply compensate for the lack of detail.

This summary does not do justice to the complex texture of Andrew Wyeth's "realisms" or to their dialectical relationship to one another. Like the weave of cloth seen from afar, they appear so seamless, so inevitable, so studied and, to some, so homogeneous, that critics are convinced his work is changeless. However, under close scrutiny, one discerns the shifts, repetitions, and ruptures that, taken over six decades, are the unique and startling fingerprint of Andrew Wyeth's art.

It is not implausible to associate some of Wyeth's expressionist watercolors with contemporaneous Abstract Expressionist paintings. Wyeth, however, never relinquishes his connection to the specific, even if that specificity is emotional rather than scenic. Moreover, despite the grandiose claims made by the Abstract Expressionists for the universality of their art, many viewers still find it—and abstraction in general—inaccessible. No such paradox attends Wyeth's work. Everyone believes that his painting is immediately comprehensible. Despite the modesty of his approach and the specificity of his subjects, both critics and admirers may know and understand Wyeth's art far less than they think.

33

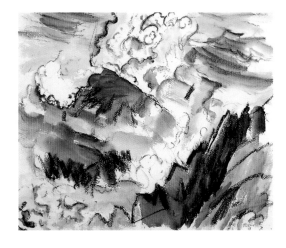

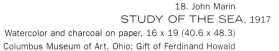

18. John Marin
STUDY OF THE SEA, 1917
Watercolor and charcoal on paper, 16 x 19 (40.6 x 48.3)
Columbus Museum of Art, Ohio; Gift of Ferdinand Howald

19. UNTITLED, 1978

Endnotes

1. Lawrence Alloway, "The Other Andy, 'America's Most Popular Painter,'" *Arts Magazine*, 41 (April 1967), pp. 20-21. Warhol would have been the better comparison, for both Wyeth and Warhol are the best-known "representational" American painters of this century. However, while Warhol courted and made the media itself his subject, Wyeth, contrary to what many critics believe, has not. A number of critics have made reference to Warhol in discussing Wyeth's work. Brian O'Doherty wrote: "the two Andys, though separated by a Grand Canyon of irony, traffic in great images rather than paintings. Both tell more about the urban and rural milieus than any other American artist. Both arouse a violent prejudice aborting them out of art history into social history and legend"; O'Doherty, "Wyeth," in *American Masters: The Voice and the Myth in Modern Art* (New York: Random House, 1973), p. 230. More recently, in discussing "the masterpiece of art world hype in the 1980s," Robert Hughes wrote that it "had nothing to do with...younger artists, or even with Andy Warhol. It centered on American art's other Andy, Wyeth..."; Hughes, *American Visions: The Epic History of Art in America* (New York: Alfred A. Knopf, 1997), p. 596.

2. Alloway, "The Other Andy," p. 21.

3. Hilton Kramer, "Shame! Brooklyn Museum Exhibits Wyeth's Dreary Pictures of Helga," *The New York Observer*, August 7, 1989, p. 17; Peter Schjeldahl, "Poor Helga," *7 Days*, September 20, 1989, p. 68.

4. Michael Kimmelman, "An Imperfect American Idol and His Self-Enclosed Art," *The New York Times*, January 17, 1997.

5. See Katherine Kuh, "Why Wyeth?," in *The Open Eye, In Pursuit of Art* (New York: Harper and Row, 1971), p. 17: "In February of 1970 Andrew Wyeth was honored by President and Mrs. Nixon with a dinner and a month-long exhibition at the White House. Said Mrs. Nixon, 'I'm a great admirer of Andrew Wyeth and so is the President.' Said Mr. Wyeth, 'I've consistently admired President Nixon and everything he stands for.' It all figures—not a surprise in a carload."

6. Florence Berkman, "Andrew Wyeth: Beloved by the Silent Majority," *Hartford* [Connecticut] *Times*, January 24, 1970.

7. Christina Kirk, "The Man Who Shuns Success," *Dallas Sunday News*, October 27, 1963.

8. Reviews of Richard Meryman's *Andrew Wyeth: A Secret Life* (New York: Harper Collins Publishers, 1996) reveal the persistence of stereotypical opinions of the artist's work: "he paints like a visitant from another time"; Anthony Haden-Guest, "Out of This World," *The Sunday Times* (London), June 15, 1997, *Books*, p. 10. Or, on the other side: "The art establishment will probably dismiss this sympathetic book..."; Harry Levins, "A Peek Inside 'Christina's World,'" *St. Louis Post-Dispatch*, February 2, 1997. One can, however, detect a positive shift, for some critics felt that the biography "should contribute to a more balanced understanding of the man and his art"; Stephen May, "Andrew Wyeth: A Secret Life," *American Arts Quarterly*, 14 (Spring 1997), p. 42. Others at least acknowledge that "whether we like Andrew Wyeth's paintings or not, they are deeply ingrained in our visual culture—important American icons"; Barbara MacAdam, "Living Up to Their Portraits," *The New York Times Book Review*, November 24, 1996, p. 8.

9. Aline Louchheim, "Wyeth—Conservative Avant-Gardist," *The New York Times Magazine*, October 25, 1953, pp. 28, 59.

10. Wanda M. Corn, *The Art of Andrew Wyeth*, exh. cat. (San Francisco: The Fine Arts Museums of San Francisco, 1973), p. 96.

11. Thomas W. Styron, *Andrew Wyeth: A Trojan Horse Modernist*, exh. cat. (Greenville, South Carolina: The Greenville County Museum of Art, 1984), p. 5.

12. George Plimpton and Donald Stewart, "Andrew Wyeth," *Horizon*, 4 (September 1961), p. 100.

13. E.P. Richardson, "Andrew Wyeth," *The Atlantic*, 213 (June 1964), pp. 63, 68.

14. Linda Nochlin, *Realism* (Harmondsworth, England, and New York: Penguin Books, 1971), p. 14.

15. John Updike, "Heavily Hyped Helga," *The New Republic*, December 7, 1987, p. 28. Updike's own problematic position vis-à-vis contemporary literature has been compared to the perception of Wyeth as a traditional realist; see Michael Paul Nesset, "John Updike and Andrew Wyeth: The Nostalgic Mode in Contemporary American Art," Ph.D. diss. (Minneapolis: University of Minnesota, 1978).

16. Richard Meryman, "Andrew Wyeth: An Interview," *Life*, May 14, 1965, p. 110.

17. Plimpton and Stewart, "Andrew Wyeth," p. 100.

18. Ibid., p. 98.

19. Meryman, "Andrew Wyeth," p. 121.

20. Andrew Wyeth, *Autobiography*, introd. by Thomas Hoving (Boston: Little, Brown and Company, 1995), p. 37.

21. Quoted in Barbara Rose, ed., *Readings in American Art 1900-1975* (New York: Praeger Publishers, 1975), p. 135.

22. Ibid., p. 111.

23. Ibid., p. 133.

24. Richardson, "Andrew Wyeth," p. 68.

25. Plimpton and Stewart, "Andrew Wyeth," p. 101.

26. Ibid., p. 100.

27. Meryman, "Andrew Wyeth," p. 108.

28. Plimpton and Stewart, "Andrew Wyeth," p. 99.

29. The consideration of Wyeth's so-called sketches and studies also raises important questions about the artist's intentions and the market demand for "finished works," whether watercolors, drybrushes, or temperas. Does Wyeth value the more refined and detailed watercolors because they were stylistically closer to the temperas and therefore in greater demand? Or did the demand for such works unconsciously cause him to sell and exhibit them more often, thus keeping the looser works out of the public eye? About *Edge of the Field*, he remarked, "it is rather astounding that I've been able to sell this kind of picture"; Wyeth, *Autobiography*, p. 39. While he is particularly addressing the bleakness and muted colors of the picture, part of the bleakness results from the roughly handled pigment and lack of a narrative subject.

30. Quoted in Bruce Robertson, *Reckoning with Winslow Homer: His Late Paintings and Their Influence*, exh. cat. (Cleveland: The Cleveland Museum of Art, 1990), p. 27.

31. Thomas B. Hess, "Wyeth's Way," *New York*, November 8, 1976, p. 82.

32. Kuh, "Why Wyeth?," p. 16.

33. Kramer, "Shame!," p. 17.

34. Corn, *The Art of Andrew Wyeth*, p. 99.

35. Doris Brian, "Is the Sharp Focus Clear?," *Art News*, 42 (March 1-14, 1943), p. 20, takes for granted the photographic technique of Wyeth's temperas: "Precision is there [in his landscapes and bird studies], perhaps even more sharply than in the hands of some other practitioners, but poetry of content and of unconventional color comes first and the camera tricks are secondary...." This notion of Wyeth's work as photographic, found elsewhere in the Wyeth literature, is refuted by Jay Jacobs, "Andrew Wyeth: An Unsentimental Reappraisal," *Art in America*, 55 (January-February 1967), pp. 24-31.

36. Adam D. Weinberg and Beth Venn, interview with the artist, December 18, 1997.

37. Dorothy C. Miller and Alfred H. Barr, Jr., *American Realists and Magic Realists*, exh. cat. (New York: The Museum of Modern Art, 1943), p. 5.

38. Ibid.

39. Ibid., p. 58.

40. Barbara Novak, *American Painting of the Nineteenth Century: Realism, Idealism, and the American Experience* (New York: Praeger Publishers, 1969), p. 280. In the interview cited above, Wyeth claimed that he didn't become aware of Luminist painting until the 1940s.

Beth Venn

Process of Invention: The Watercolors of
ANDREW WYETH

In any given year, Andrew Wyeth paints only two to four temperas, each taking as long as six months to complete. Yet in the same period he produces between fifty and one hundred watercolors. Why then is it as a master of the tempera medium that Wyeth has earned his reputation as America's most popular painter? While quantity alone is no guarantee of significance, the sheer amount of time the artist spends in the company of watercolor demands a closer study of these works.

For anyone familiar only with Wyeth's temperas, a survey of the works in his "other" medium is surprising. Spanning more than sixty years, his watercolors display such variety and invention that we wonder if this body of work—now totaling several thousand—could have been painted by the same hand. Watercolor painting is Wyeth's visual equivalent of conceiving and formulating an idea; he will dash off quick studies on whatever paper is at hand, or explore a subject more deeply, noting patterns of light, coloration, and form. Watercolor is a medium in which Wyeth feels free to experiment, to reveal what he calls his "wild side."[1] In the process, we gain precious evidence about how he sees and translates lived experience.

It was watercolor that brought Wyeth his first taste of success in 1937, when his Macbeth Gallery exhibition, composed entirely of watercolors, sold out in a single day. Critics found him to be "a watercolorist of quite exceptional ability," noting that "his work inevitably challenges comparison with that of our greatest in his field—men like Winslow Homer and John S. Sargent."[2] But as a young, twenty-year-old artist, Wyeth naturally explored other media and methods, including tempera, taught to him by his brother-in-law, Peter Hurd, and drybrush watercolor, which he learned by studying reproductions of work by such masters as Albrecht Dürer. By 1943, with the inclusion of five of his temperas in the important "American Realists and Magic Realists" exhibition at New York's Museum of Modern Art and, five years later,

the same museum's purchase of CHRISTINA'S WORLD (Fig. 1, 61), Wyeth's reputation as a master of the tempera medium was born.

Wyeth's successful 1937 watercolor show was followed by two more well-received shows at Macbeth in 1939 and 1941. In 1938, Wyeth made his museum debut when one of his watercolors was chosen for that year's Whitney Museum Annual. This critical acclaim for his watercolors was soon forgotten. Scholars who chronicled his life and art from the fifties through the seventies often dismissed these works as merely "intermediate" or as "steps on the road to another goal."[3] The early watercolors, such as Figs. 21, 44, and those with loose, expressionist brushwork were almost categorically ignored. Wanda Corn, for example, focused on Wyeth's temperas of the early 1940s as "his first major period as an artist."[4] Perry Rathbone noted only Wyeth's tightly rendered, "tempera-like" watercolors when he wrote: "Wyeth's mature work has largely been expressed in the mediums of egg tempera and dry brush watercolor."[5]

The dismissal of Wyeth's watercolors is due largely to an assumed progression in which Wyeth's watercolors figure as a kind of warm-up—the working out of a subject—to the temperas, which represent the ultimate manifestation of an idea. And while some watercolors do function as studies for more finished works, many constitute complete and finished compositions. For Wyeth, the distinction between a study or sketch and a finished work is not always clear. He recently explained that, when embarking on a watercolor, he never knows if it will become a final work in its own right, or serve as a study for a more fully composed watercolor or tempera.[6]

This first opportunity to examine sixty years of Andrew Wyeth's watercolors yields several truths about his work in the medium.[7] For one, Wyeth never completely abandoned the loose

38

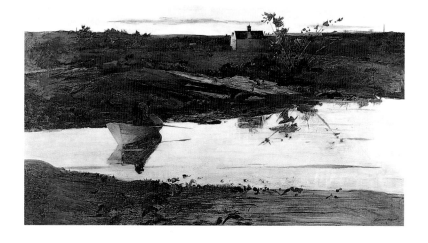

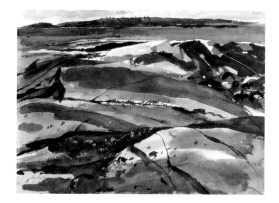

20. MORNING LOBSTERMAN, 1939
　　　Tempera on panel, 27 x 47⅞ (68.6 x 121.6)
　　　Collection of Andrew and Betsy Wyeth

21. UNTITLED, 1938

fluid style that characterized his earliest works; it surfaces throughout his career in some of his most powerful images. He also never settled on one signature style, but rather continues to employ a wide range and variety of working methods. Third, he never divorced his work in watercolor from that in tempera, but consistently shifts back and forth between the two, allowing one medium to inform the other.

The very genesis of Wyeth's temperas can be found in the watercolors. "I was very much really painting them like watercolors....I think [tempera] is a natural development of watercolor."[8] MORNING LOBSTERMAN (1939; Figs. 13, 20), one in a series of temperas from the late 1930s, is testament to the way Wyeth's watercolors led him to tempera. The long, horizontal washes, flat unmodulated colors, very high horizon line, and the abstracted quality of foreground details such as fallen leaves recall a 1938 untitled watercolor (Fig. 21).

By the early 1940s, Wyeth had refined his tempera technique, adding detail, building up and solidifying figures and objects, and leaving behind the abstracted suggestion of form that characterized his earlier work. In the tempera WINTER FIELDS of 1942 (Figs. 22, 65), the sharp detailing of each length of weed and each feather of the bird becomes the subject of the painting. By comparison, in MORNING LOBSTERMAN the artist seems to have been attempting to capture the mood and stillness of morning's first light rather than render a detailed account of the scene.

Wyeth's temperas continued to move in a more rigorous and controlled direction. By 1953, the artist Elaine de Kooning, chronicling Wyeth's process of tempera painting, wrote: "holding his brush like a pencil, resting the heel of his hand on the board, he makes his strokes with finger movements." Applying tiny dashes of pigment, he "worked mainly with one very fine brush of camel's hair, less than

39

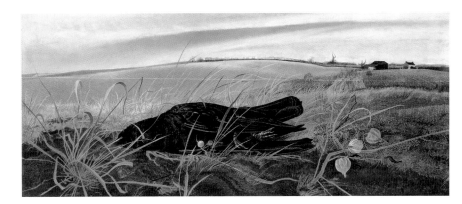

22. WINTER FIELDS, 1942

half-an-inch long, which he splayed so that it left four clearly defined strokes, each the width of a pen line."[9] Wyeth's watercolor method, by contrast, requires constant shifts and transitions. From wet application to dry, from broad stroke to stippled detail, from heavily layered pigment to light washes of color, he chooses the technique that best suits the expressive needs of the image—and frequently incorporates a variety of methods in a single picture. In an untitled watercolor of 1978 (Figs. 19, 23, 137), he records his impression of a pool deep in the woods. In the upper right, washy veils of undulating gray blend a crisp winter sky into the darkness of the dense trees. Strokes of a wide, loaded brush define the left bank of the pond, while the icy chill of the water is accomplished by quick, light strokes of a semidry brush. The deep black bank to the right of the water is solidly applied, with heavy pigment, possibly squeezed directly from the tube. Along this thick and cracking black, the artist has scraped small patches down to the white paper, creating the effect of tiny points of light peeking through the branches above. Along the water's left edge, he details green and black brambles with dashed strokes of a small brush. In the center background, a warm wash of yellow brown, contrasting sharply with the heavy blacks surrounding it, glows like light coming through the trees.

Unlike his temperas, whose stillness, precision, and hyperreal detailing are immediately identifiable as "Wyeth," the watercolors exhibit little in the way of a signature style. The fluid, wet-on-wet painting seen in the watercolors of the late 1930s and the more exacting drybrush method begun in the early 1940s are inadequate measures of the incredible range of techniques Wyeth employs. Technique, he once said, "is not what interests me. To me, it is simply the question of whether or not I can find the thing that expresses the way I feel at a particular time...."[10] In Wyeth's working method, in other words, technique is always put in the service of visual experience, not of mere effect. In some instances, it may serve his purpos-

40

23. UNTITLED, 1978

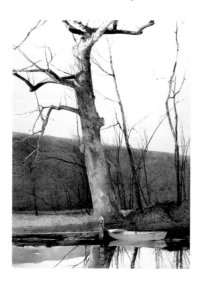

24. COLD SPRING, 1988

es to simply sketch out the rough composition of a scene, as in the 1957 UNTITLED (Study for BROWN SWISS) (Fig. 81). In others, he first lays down a broad, wet background of color, applying detail with additional applications of watercolor. To this, he often adds another layer of paint, rendered in the more refined drybrush method (HOFFMAN'S SLOUGH STUDY, 1947; Fig. 79). In the drybrush COLD SPRING (1988; Figs. 24, 153), the bank along the water and the background hill show Wyeth using drybrush to describe minute detail and to separate the foreground and background planes. The freer handling of paint in the tree and boat and the stark white of the sky sharply contrast with the finely modulated tones of the drybrush passages. Here as elsewhere, Wyeth formulates mood not through a dramatic color scheme but through varying the treatment and texture of his medium.

To achieve his drybrush technique, Wyeth squeezes excess watercolor from a brush filled with color, then applies it as a virtually dry pigment. It is a slower and more refined practice that, in effect, most resembles his work in tempera. But the transparency of the watercolor medium, even when applied dry, allows for wonderfully rich and complex layers of color. A detail of the grassy field in the drybrush HOAR FROST (1995; Figs. 25, 161) appears as a stippled overall pattern, the grass being rendered suggestively in a kind of shorthand. By contrast, in the tempera LOVE IN THE AFTERNOON (1992; Figs. 26, 156), the grass takes on a more hyperrealist quality, in which each blade receives individual attention. In watercolor—even in the most detailed drybrush—Wyeth paints the suggestion of things; in tempera, he renders. The curious contradiction here is that Wyeth paints outdoors when working in watercolor, among the subjects he is portraying. But rather than capture each blade, highlight, and shadow, he paints an impression. In his studio, he calls upon recent studies as well as an accumulated memory of nature—he has been studying grasses for over fifty years (Fig. 64)—to realistically duplicate his subject in tempera.

41

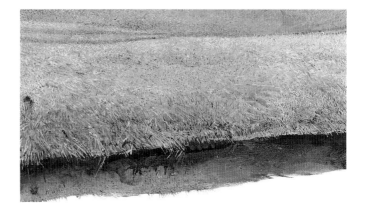

25. HOAR FROST, 1995 (detail) 26. LOVE IN THE AFTERNOON, 1992 (detail)

Moving between styles, Wyeth regularly revisits the free and loose manner of his earliest watercolors, working quickly to capture shapes, light, or shadow (CIDER APPLES, 1963; Fig. 109). So free is he of studied mannerisms that he admits, "half the time I don't even see what I'm doing."[11] When he is after a specific effect, such as leaves floating in a stream (FLOATING LEAVES, 1958; Fig. 90) or the highlights and shadows among the craggy, dense masses of a rocky shore (UNTITLED, 1950; Fig. 92), his rapid paint handling serves to describe the fleeting nature of the scene.

But Wyeth is also an artist who studies his subject intensely. And he often finds watercolor—its flexibility, its varied techniques and transparencies—highly appropriate for this investigative approach. Off to the side of a pencil study of a hill on a winter day, he wrote: "deep wet earth soaking up the snow as it falls....The moving shadows of snow clouds pass."[12] In a drybrush study of this scene (FLOCK OF CROWS [Study for SNOW FLURRIES], 1953; Fig. 27), these are precisely the effects he captures. The snow lies in various stages of melting, appearing as a stippled stark white in some places, a white melting into brown in others. Off to the left, brown and gray, applied wet and diluted, puddle and soak the background. The blurry gray of the sky displays only the vague outlines of clouds.

Most of Wyeth's studies begin in an attempt to capture an impression, an object, the effect of light and shadow, the color of a field or a rocky shore at a certain time of day. He may find that a particular shape of land catches his eye, like the natural curve of a sandspit in UNTITLED (SANDSPIT STUDY) (1953; Figs. 28, 116). He began this work, as he often does, with a quick pencil sketch that was soon covered in loosely painted watercolor to block out shapes, the general tonal range, and the balance of forms. Splashed and splattered tan pigment, along with tiny, penciled stones and shells in the foreground

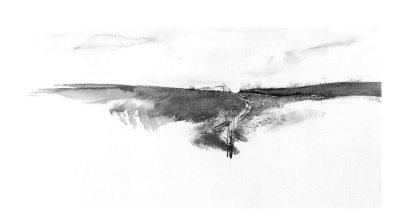

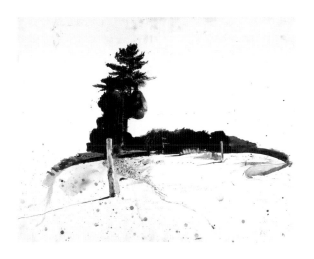

27. FLOCK OF CROWS (Study for SNOW FLURRIES), 1953
Drybrush on paper, 10 x 19½ (25.4 x 49.5)
Collection of Andrew and Betsy Wyeth

28. UNTITLED (SANDSPIT STUDY), 1953

44

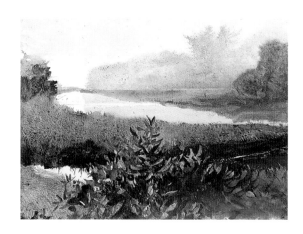 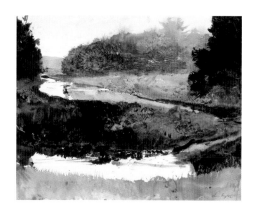 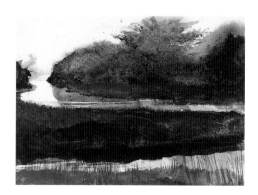

29. BACKWATER, 1982
 Watercolor on paper, 20¼ x 28 (51.4 x 71.1)
 Private collection

30. UNTITLED (BACKWATER STUDY), 1982

31. BACKWATER (STUDY), 1982

suggest the texture of the ground surface. To this is added a short, written description: "fine sand...white clam shells...and larger stones quite blue-gray." This manner of shorthand—loose sketch overlaid with quickly brushed watercolor followed by a brief written notation—is just reminder enough to allow Wyeth to transfer the spontaneous quality of the study to the finished work (SANDSPIT, 1985).

Wyeth's process of creating watercolor studies is not always predictable. Though it is often thought that his watercolors serve as studies for his temperas, it is not uncommon for a group of watercolors to lead to a final work in the same medium. The 1982 watercolor BACKWATER (Fig. 29) is a detailed and finished composition. The studies, UNTITLED (BACKWATER STUDY) and BACKWATER (STUDY) (Figs. 30, 145 and 31, 139) show Wyeth building up the detail in progressive stages to the fully realized scene. At other times, he does not follow this type of progression. In Fig. 32 of 1985, he painted the broader scene first before moving closer and capturing an impression of the tree's shadow falling against the white side of the building (UNTITLED, 1985; Figs. 33, 150).

Wyeth regards his watercolors as anything but precious. Tears frequently appear along the edges and many are creased or smudged. Working at a furious pace, he may hurl one study to the ground and quickly take up another. Typically, his watercolors begin—and end—outdoors. He prefers not to use an easel, propping his paper on a sheet of cardboard for support. "I may smear my coat across it... or throw it in the bushes and the bushes get stuck [on it],"[13] he said, dismissing the hazards of this approach. Some watercolors painted thirty-five years ago still have weeds and leaves embedded in the paint (UNTITLED [DISTANT THUNDER STUDY], 1961; Figs. 34, 102). Along all four edges of many watercolors, there appear drips. In easel painting, the drips would only roll down the page toward the bottom edge. That they appear on all sides

45

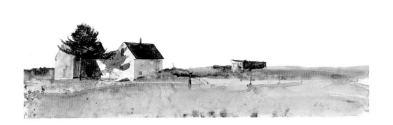

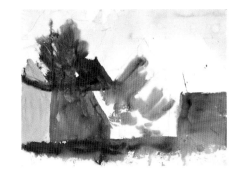

32. UNTITLED, 1985 33. UNTITLED, 1985

indicates that Wyeth turns his paper ninety degrees while working, or casts it away before the paint is dry (UNTITLED, 1963; Figs. 35, 112). When working in his studio on a tempera painting, watercolor studies dot the floor around him and he walks across them. At least one still bears the barely visible print of the sole of his shoe (UNTITLED [RIVER COVE STUDY], 1958; Fig. 86).

It is not uncommon for Wyeth to use his fingers to create a stipplelike detail, or the heel of his hand to coax the paint around on the paper. In many works, to form highlights, he scrapes through the pigment down to the white of the paper with his thumbnail. In two quick 1957 watercolor sketches of a Pennsylvania hill and stream, UNTITLED (Study for BROWN SWISS) (Figs. 36, 99 and 37, 98), Wyeth worked on smooth paper that did not absorb the paint as readily as the traditional, more rough-surfaced, watercolor paper. As the paint sat wet, he could manipulate it to create detail and texture. Smudging with his fingers along the bank above the water in both images, he defined a rough patch of bushes. In the foreground of Figs. 36, 99, he poked at the paint with the bristles of a wide brush, giving a modulated, rippled texture to the land. Paint scraped away on the far right side of Figs. 37, 98 outlines a small tree, while the same method creates highlights on the water in Figs. 36, 99 (a more rigorous scraping can be seen on the rocks in UNTITLED, 1950 (Fig. 92). Dismissing any form of structured, academic approaches to the medium, Wyeth simply engages whatever device gives the desired effect.

Wyeth's watercolors can be as dense and darkly painted as EASTMAN'S BROOK (1971; Fig. 135) or as light and calligraphic as UNTITLED (1980; Fig. 142). In either case, his contention that his "real nature—messiness"[14] is what comes out in the watercolors seems only a half-truth. Restraint is everywhere evident in the watercolors, since mistakes cannot be covered over as they can in opaque media

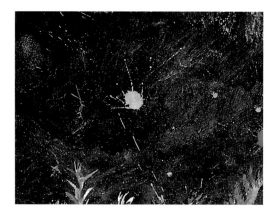

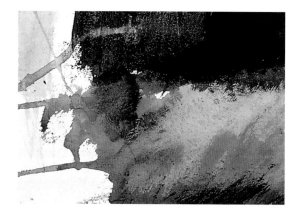

34. UNTITLED (DISTANT THUNDER STUDY), 1961 (detail)

35. UNTITLED, 1963 (detail)

such as oil and tempera. In EASTMAN'S BROOK, tiny specks of white emerge, barely escaping being filled in by a sea of black. The delicate branches in Fig. 142 do not suffer from overworking. Single strokes of a brush, without overpainting or detailing, give them just the right weight. It is this kind of control in Wyeth's working method that challenges the belief that tempera is his more demanding and painstaking medium. In watercolor, Wyeth is presented with more options, more ways to accomplish a desired effect.

Years ago, Lincoln Kirstein said to Wyeth: "You're wasting your time in watercolor, it's a light medium."[15] Despite this admonition, Wyeth persisted. He has always viewed watercolor as much more than a mere collection of studies or a thread that connects his work in tempera. Watercolor became for him a method of seeing and thinking about an object or scene. Yet his temperas have garnered the bulk of attention from critics, museums, and the public, while his watercolors have remained in the background. Despite his deep committment to the medium, or perhaps because of it, he has been satisfied with keeping most of his watercolors to himself, "rarely...allow[ing] his working self to be seen."[16] The opportunity to view with a fresh eye this complex and masterful oeuvre, nearly six decades in the making, is a rare experience indeed.

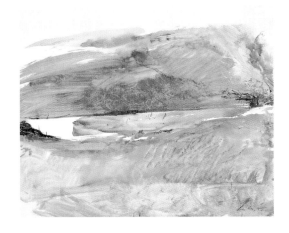

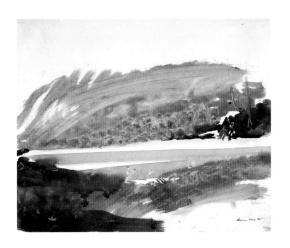

36. UNTITLED (Study for BROWN SWISS), 1957 37. UNTITLED (Study for BROWN SWISS), 1957

Endnotes

1. "My wild side that's really me comes out in my water-colors"; quoted in Richard Meryman, "Andrew Wyeth: An Interview," *Life*, May 14, 1965, p. 108.

2. Royal Cortissoz, in *The Art Digest*, 12 (November 1, 1937), p. 15; James K. Brown, in *Art in America*, 26 (January 1938), p. 41.

3. Agnes Mongen, introduction to *Dry Brush and Pencil Drawings*, exh. cat. (Cambridge, Massachusetts: Fogg Art Museum, 1963), n.p.

4. Wanda Corn, *The Art of Andrew Wyeth*, exh. cat. (San Francisco: The Fine Arts Museum of San Francisco, 1973), p. 130.

5. Perry T. Rathbone, *Andrew Wyeth*, exh. cat. (London: Lefevre Gallery, 1974), p. 2.

6. Adam D. Weinberg and Beth Venn, interview with the artist, December 18, 1997.

7. Not since the 1960s, with exhibitions such as "Andrew Wyeth: Temperas, Water Colors and Drawings," at the Albright-Knox Art Gallery (1962), and "Andrew Wyeth: Dry Brush and Pencil Drawings," at the Fogg Art Museum (1963), have Wyeth's watercolors and drybrush works been exhibited in large numbers in a museum exhibition. We are indebted to Mary Adam Landa, curator of the Wyeth Collection, for making both reproductions and many original works from Wyeth's entire oeuvre available for our selection.

8. Weinberg and Venn, interview.

9. Elaine de Kooning, "Andrew Wyeth Paints a Picture," *Art News*, 49 (March 1950), p. 54.

10. Quoted in Thomas Hoving, *Two Worlds of Andrew Wyeth: Kuerners and Olsons*, exh. cat. (New York: The Metropolitan Museum of Art, 1976), p. 30.

11. Weinberg and Venn, interview.

12. Notation on pencil sketch, Study for *Snow Flurries* (1953), reprod. in Betsy James Wyeth, *Wyeth at Kuerners* (Boston: Houghton Mifflin Company, 1976), p. 314.

13. Weinberg and Venn, interview.

14. Quoted in Meryman, "Andrew Wyeth," p. 108.

15. Weinberg and Venn, interview.

16. Wyeth, *Wyeth at Kuerners*, p. viii.

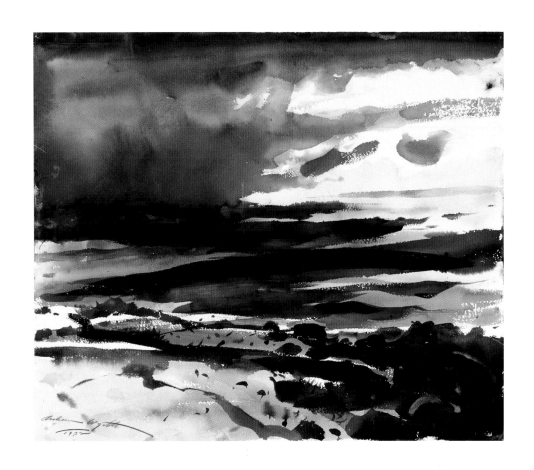

38. COMING STORM, 1938
Watercolor

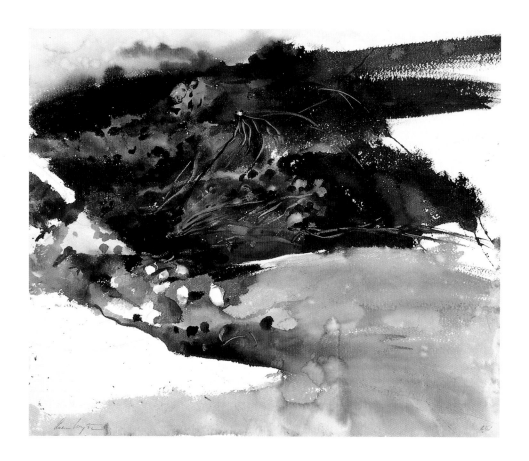

39. UNTITLED, 1939
Watercolor

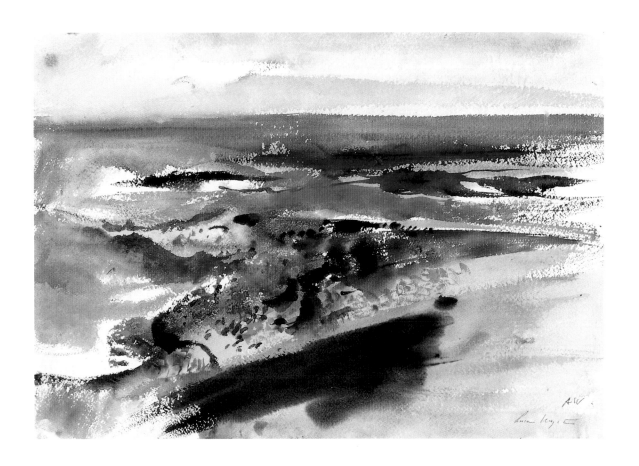

40. UNTITLED, 1939
Watercolor

41. CLUMP OF MUSSELS, 1939
 Watercolor

54

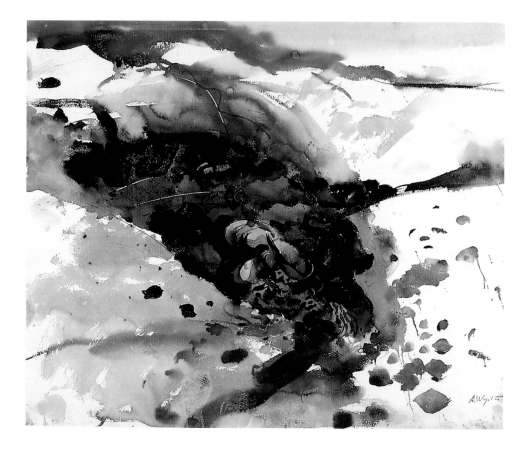

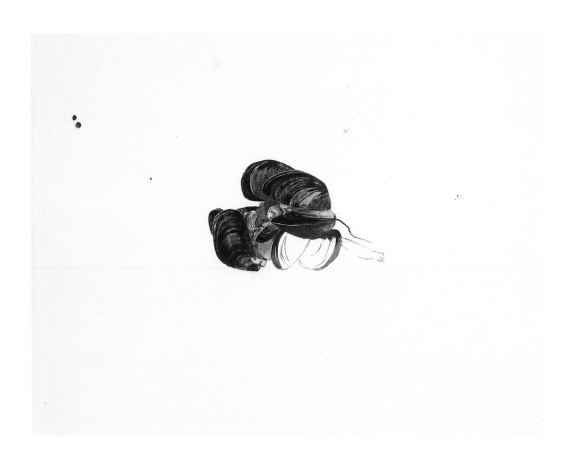

42. MUSSELS, 1940
Ink and watercolor

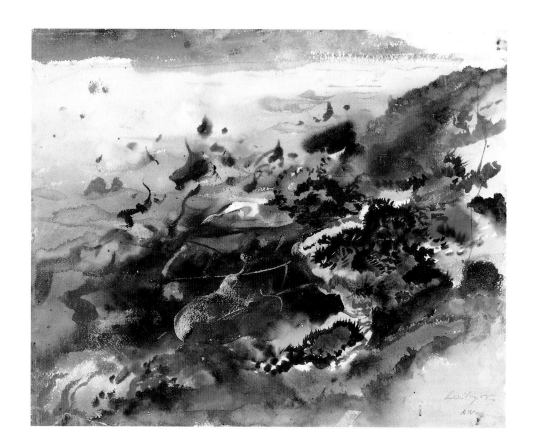

43. UNTITLED, 1939
Watercolor

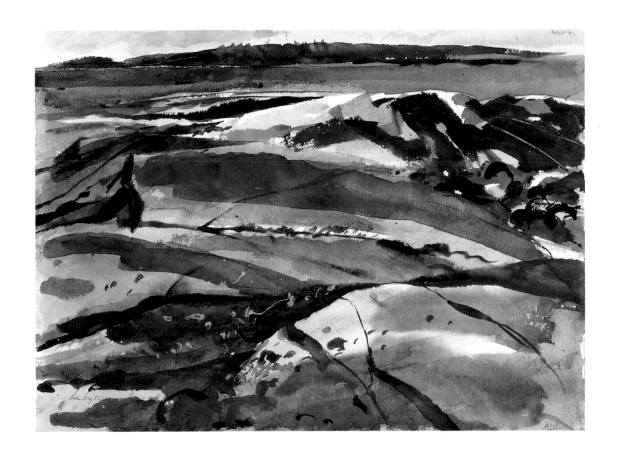

44. UNTITLED, 1938
Watercolor

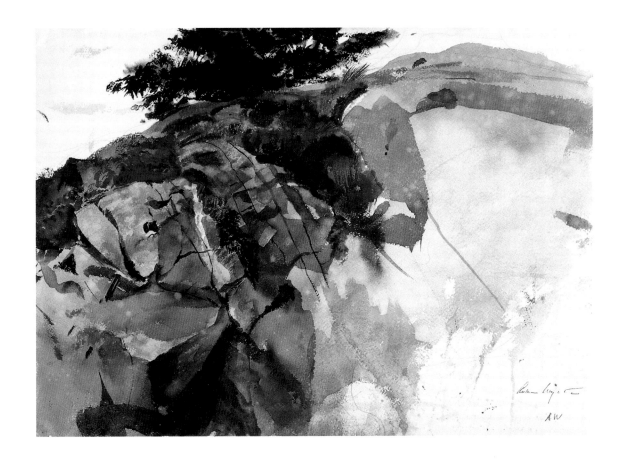

46. UNTITLED, 1939
Watercolor

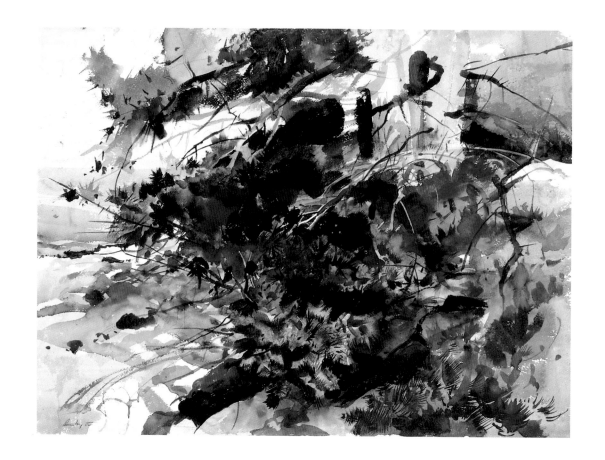

47. UNTITLED, 1939
Watercolor

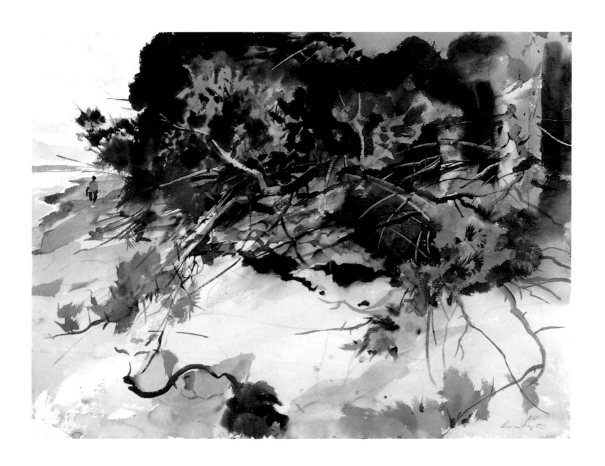

48. UNTITLED, 1939
Watercolor

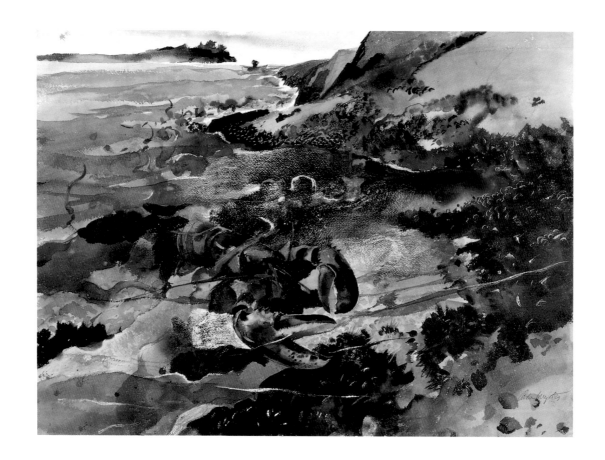

49. UNTITLED, 1940
Watercolor

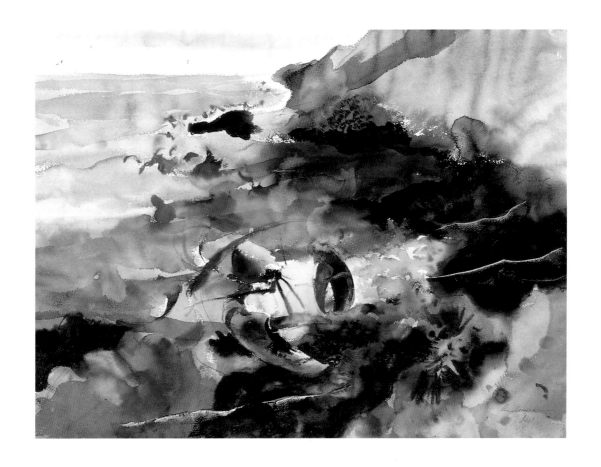

50. UNTITLED, 1940
Watercolor

51. KELP, 1940
 Watercolor

66

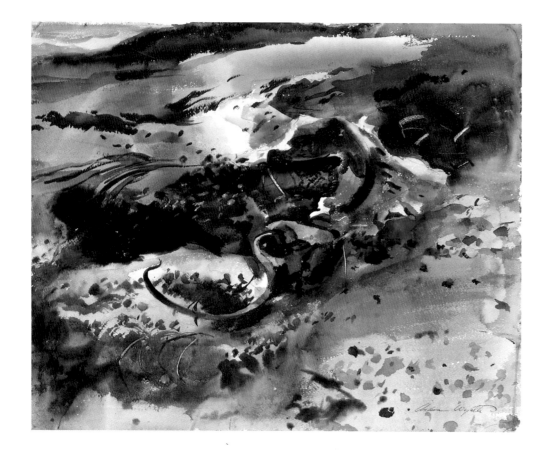

52. SCULPIN, 1938
Tempera

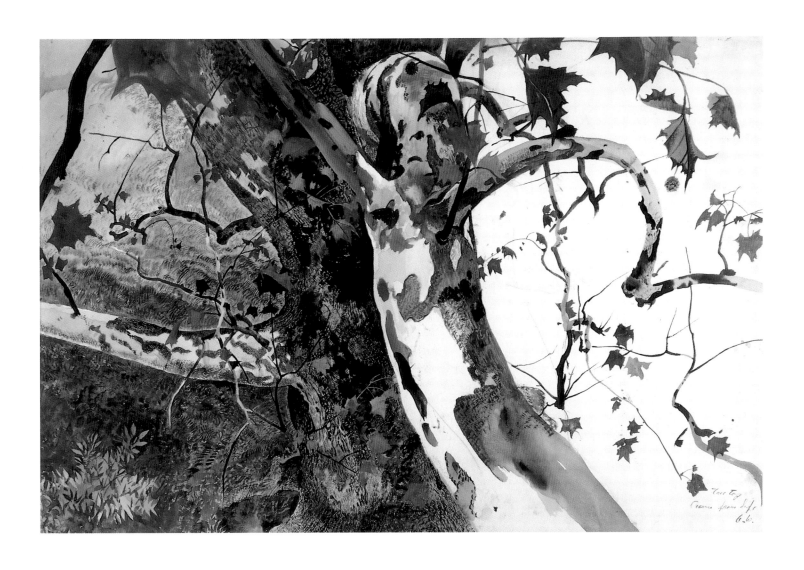

53. BUTTONWOOD (Study for THE HUNTER), 1943
Drybrush

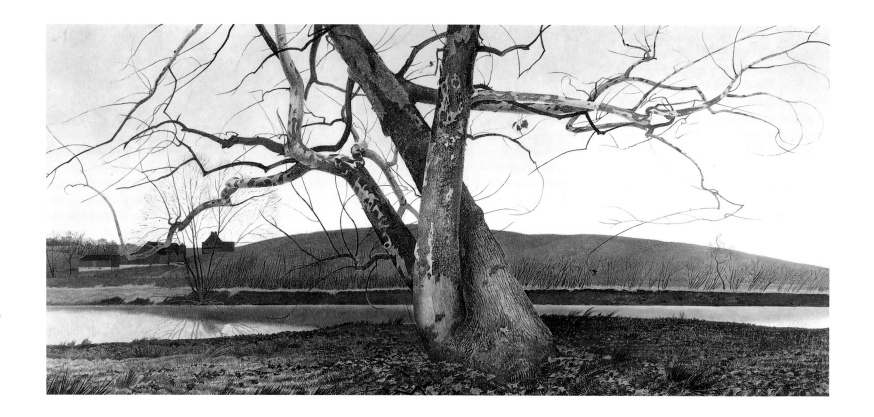

54. DIL HUEY FARM, 1941
Tempera

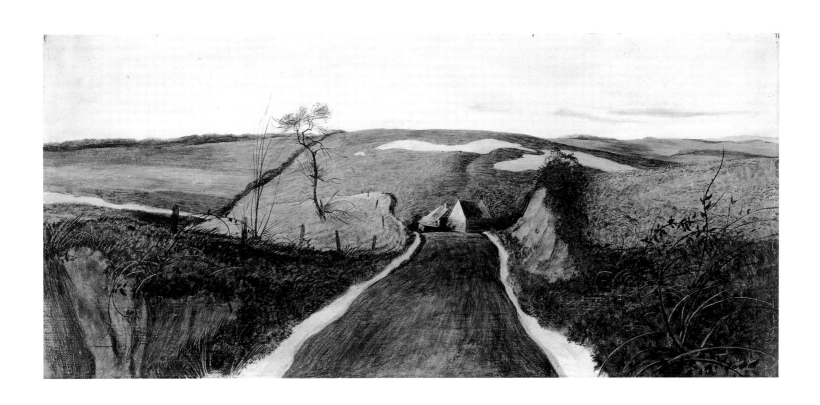

55. ROAD CUT, 1940
Tempera

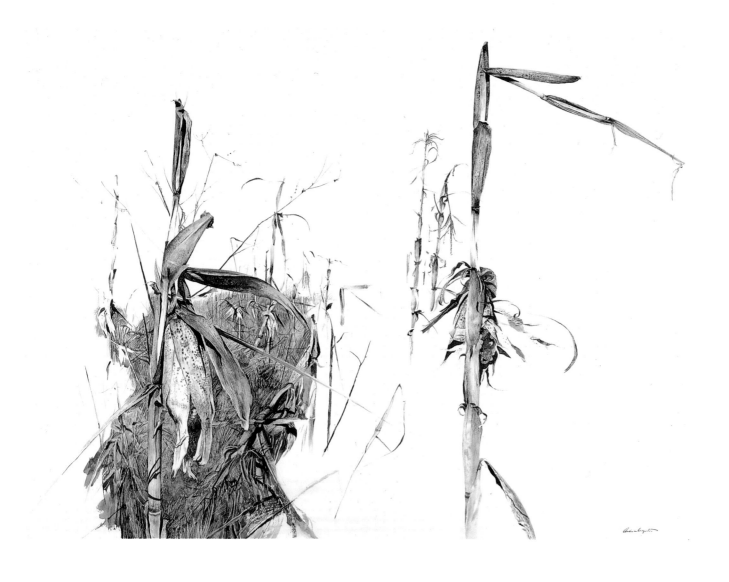

56. WINTER CORN, 1948
 Drybrush

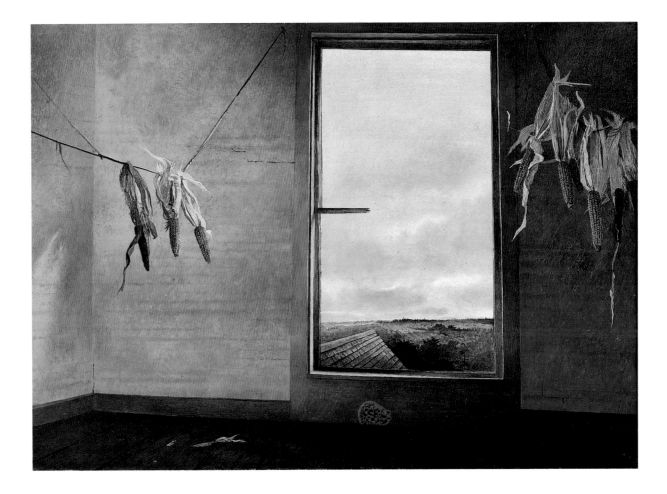

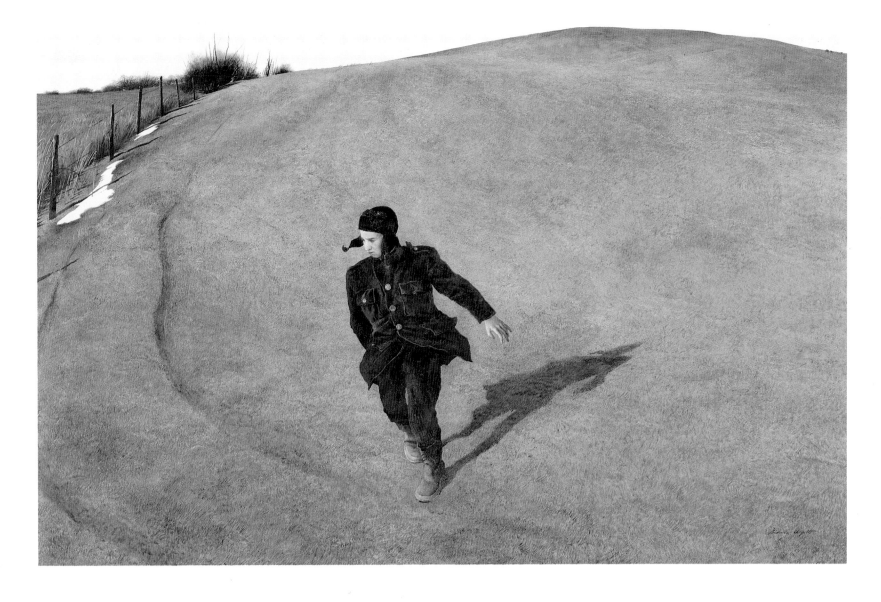

59. HOFFMAN'S SLOUGH, 1947
 Tempera

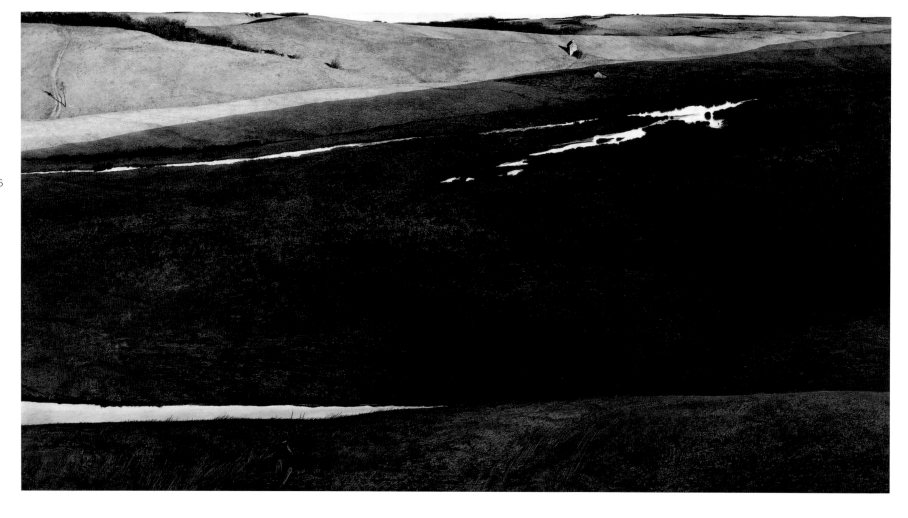

60. SOARING, 1950
Tempera

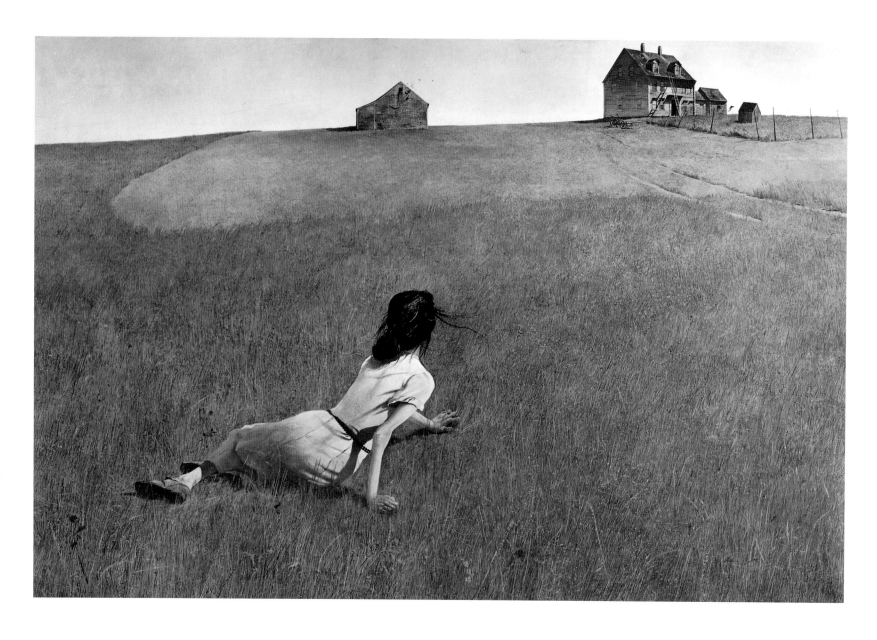

61. CHRISTINA'S WORLD, 1948
 Tempera

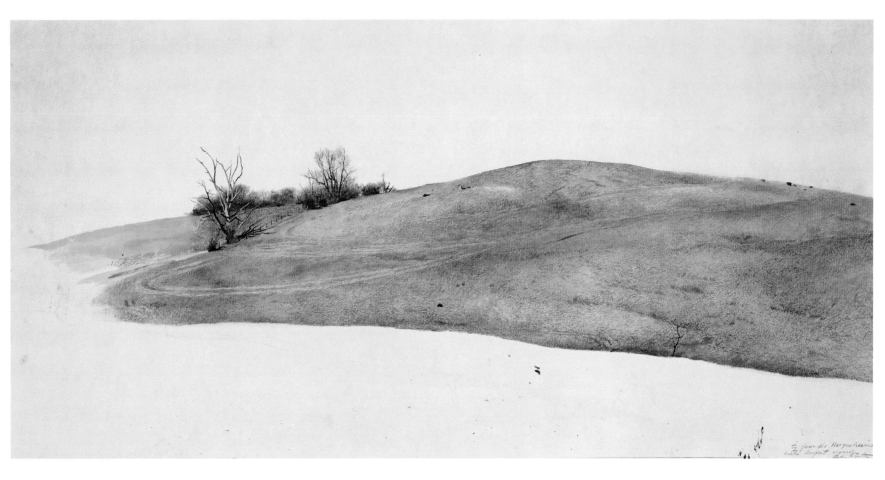

62. KUERNERS HILL (Study for WINTER), 1946
Drybrush

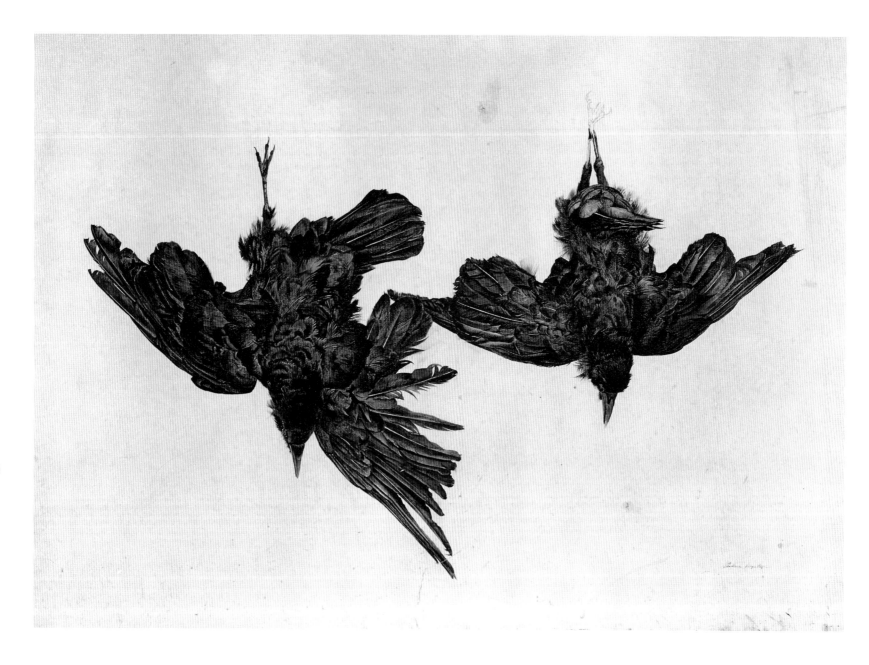

63. CROWS (Study for WOODSHED), 1944
Gouache and ink

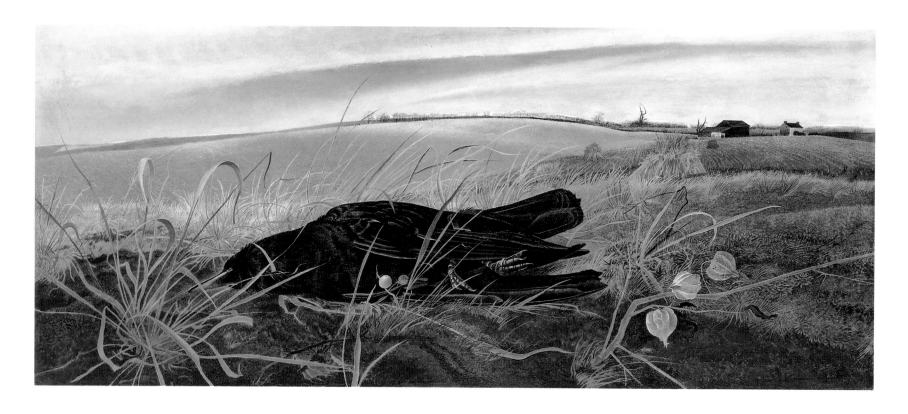

82

65. WINTER FIELDS, 1942
 Tempera

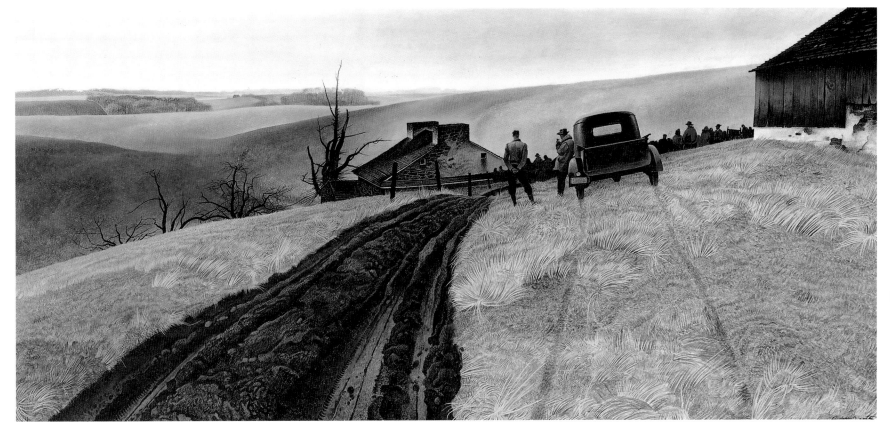

66. PUBLIC SALE, 1943
Tempera

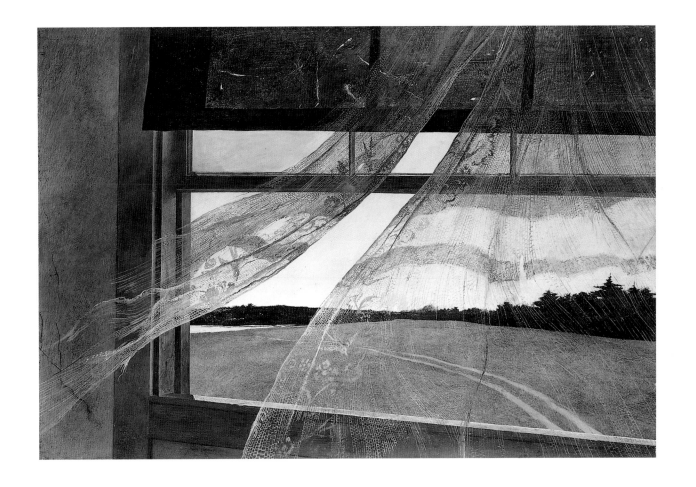

67. WIND FROM THE SEA, 1947
Tempera

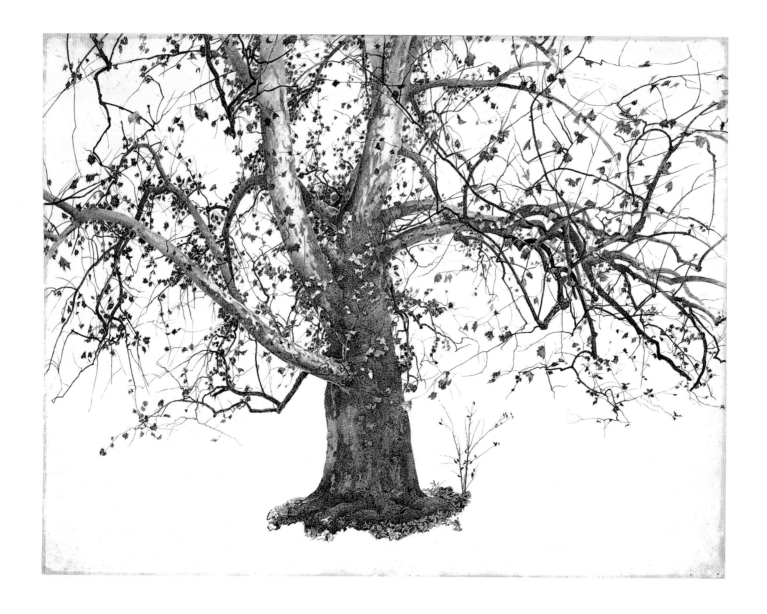

68. SYCAMORE TREE (Study for PENNSYLVANIA LANDSCAPE), 1941
Ink and drybrush

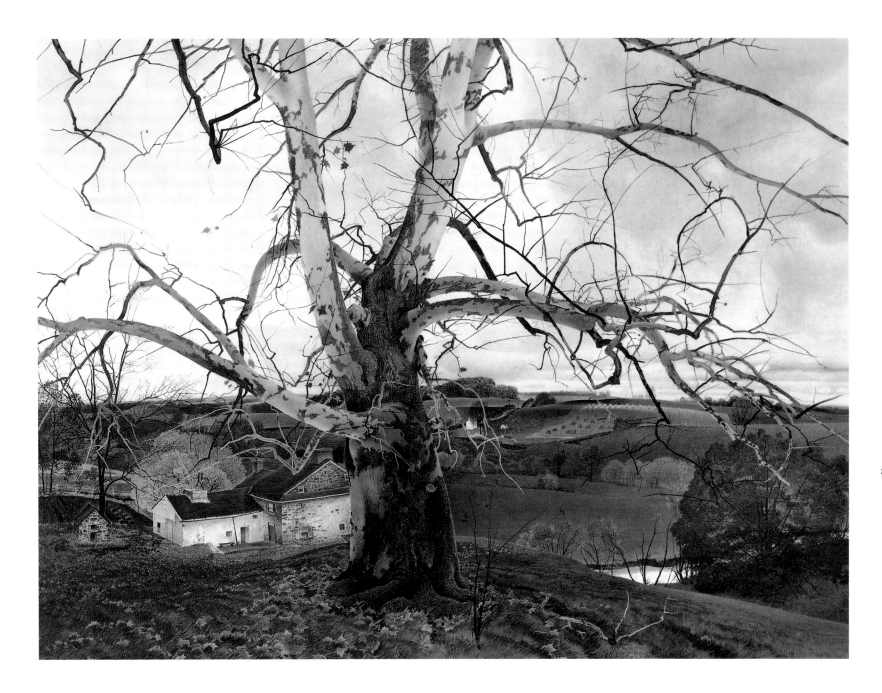

69. PENNSYLVANIA LANDSCAPE, 1942
Tempera

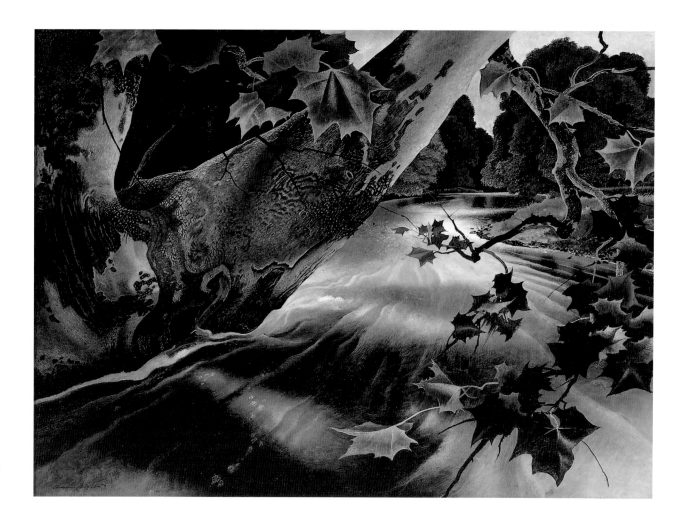

88

70. SUMMER FRESHET, 1942
 Tempera

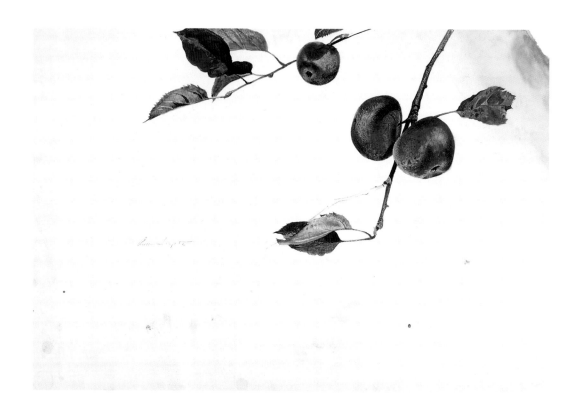

72. APPLES ON A BOUGH, 1942
Drybrush

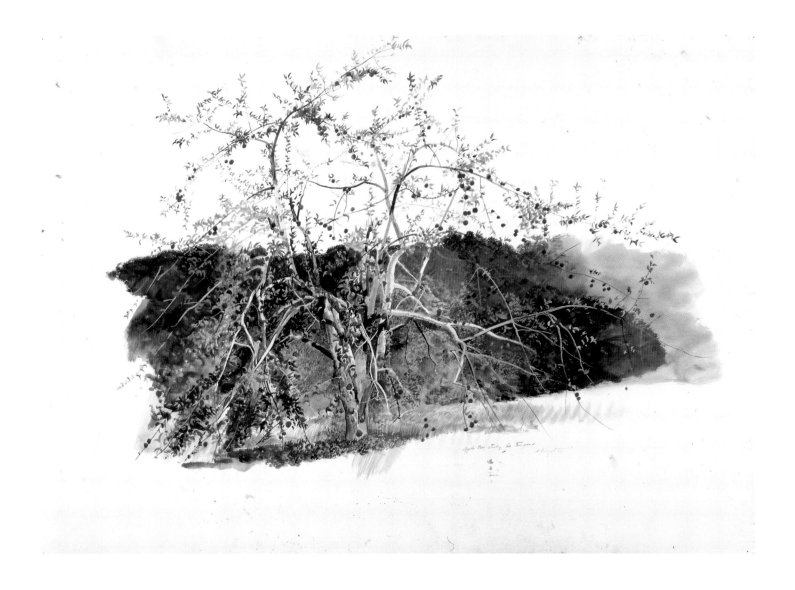

73. BEFORE PICKING, 1942
Drybrush and watercolor

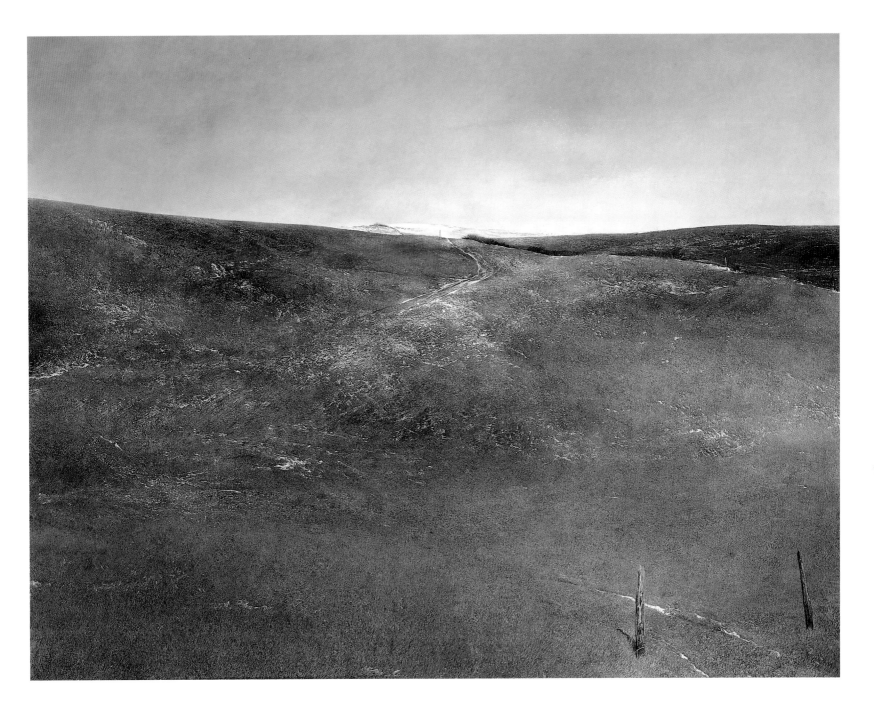

93

74. SNOW FLURRIES, 1953
Tempera

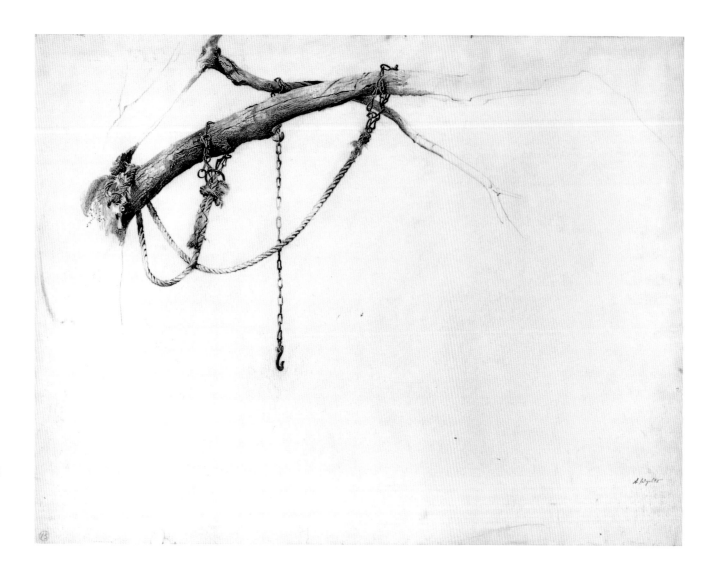

94

75. ROPE AND CHAINS (Study for BROWN SWISS), 1956
 Graphite

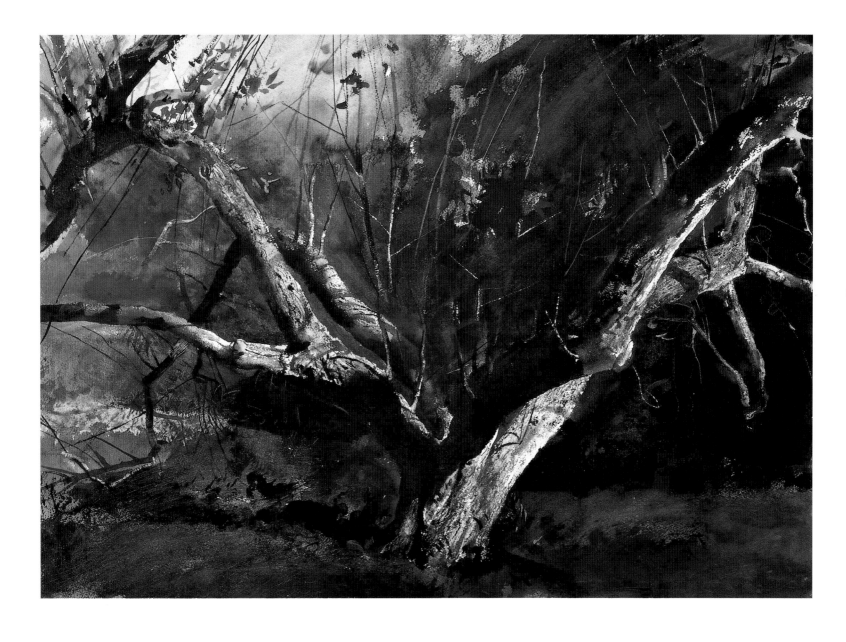

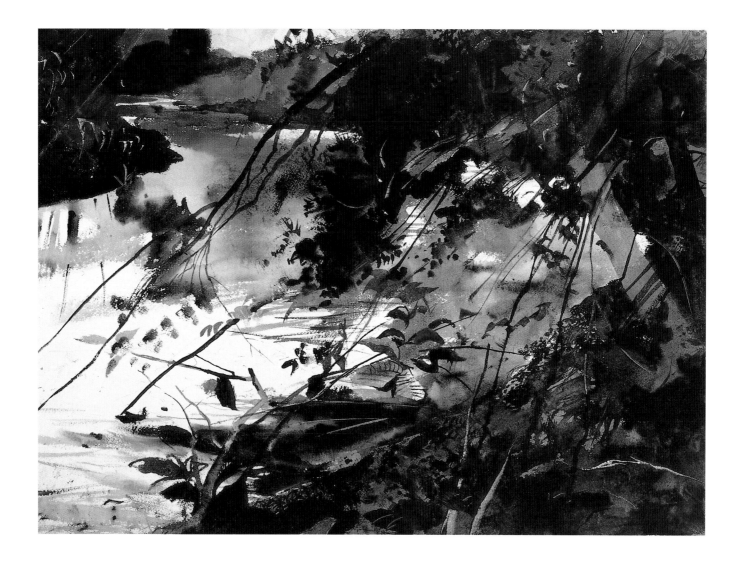

77. UNTITLED, 1950
Watercolor

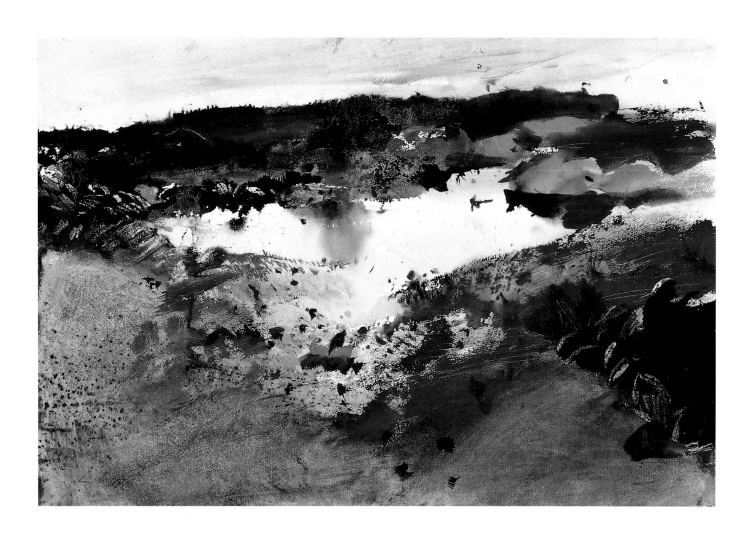

78. UNTITLED, 1951
Watercolor

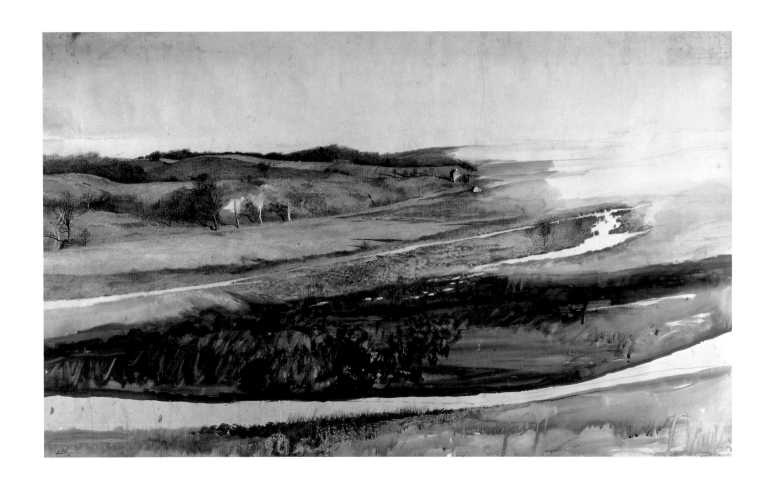

79. HOFFMAN'S SLOUGH STUDY, 1947
 Drybrush

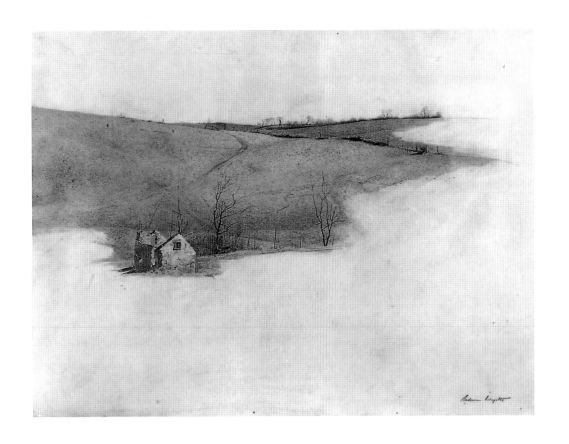

80. ARCHIES CORNER, 1953
Graphite

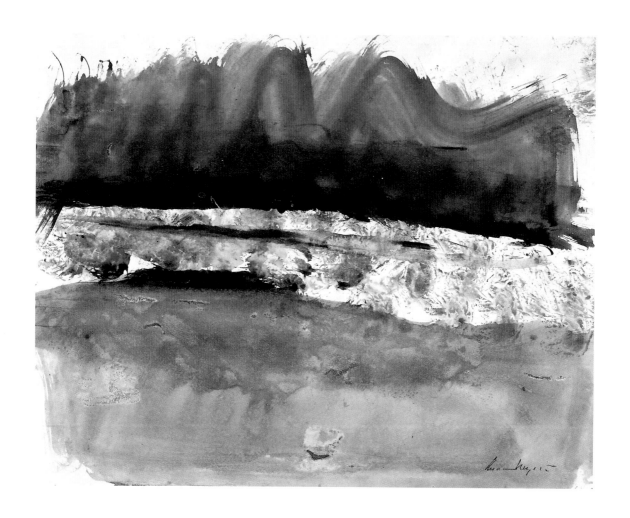

81. UNTITLED (Study for BROWN SWISS), 1957
 Watercolor

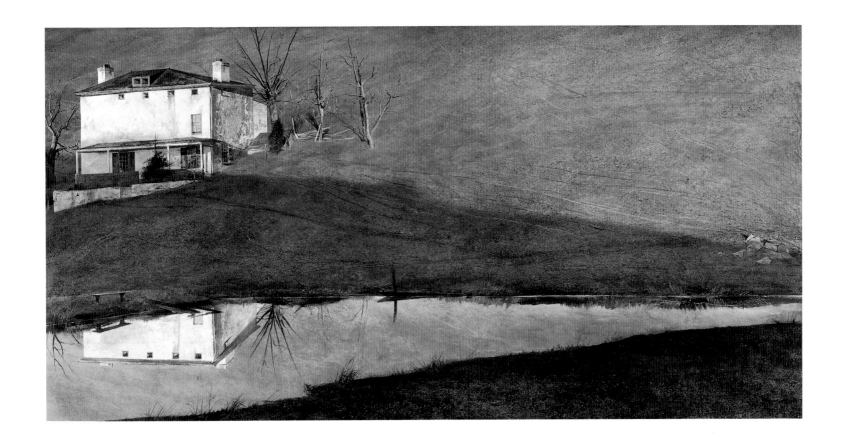

82. BROWN SWISS, 1957
Tempera

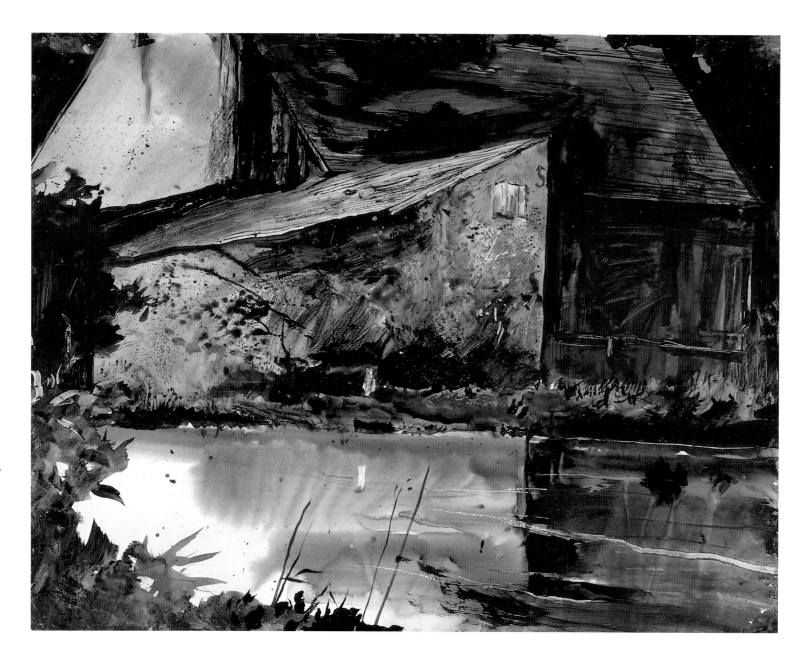

85. UNTITLED, 1953
 Watercolor

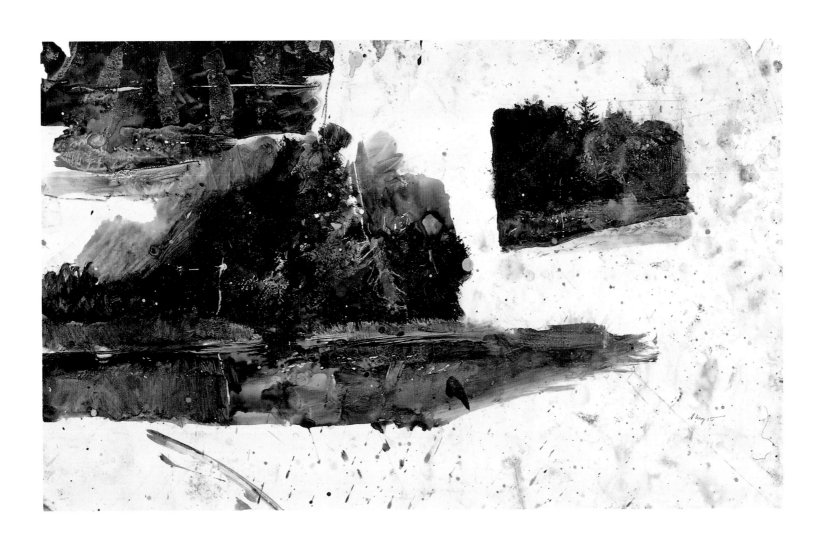

86. UNTITLED (RIVER COVE STUDY), 1958
Watercolor

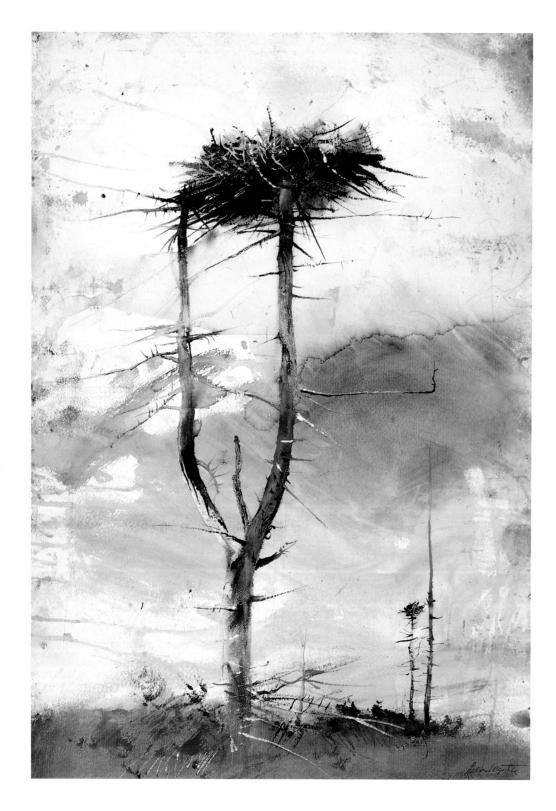

87. UNTITLED, 1954
Watercolor

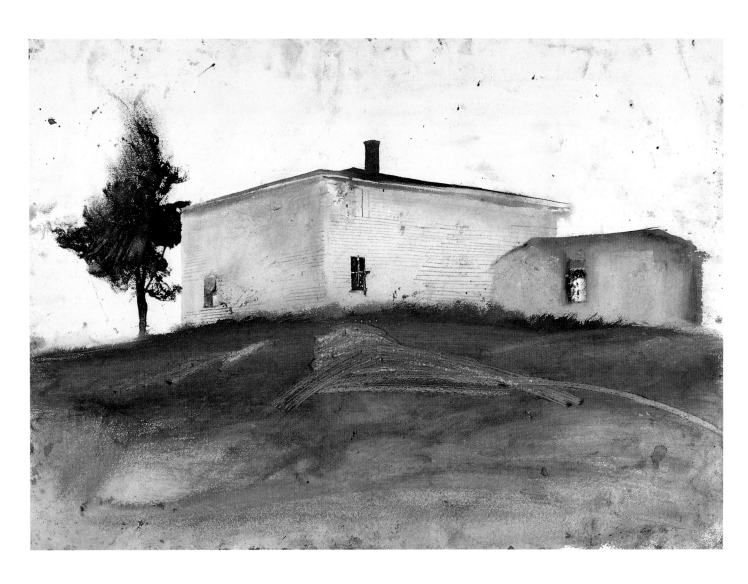

109

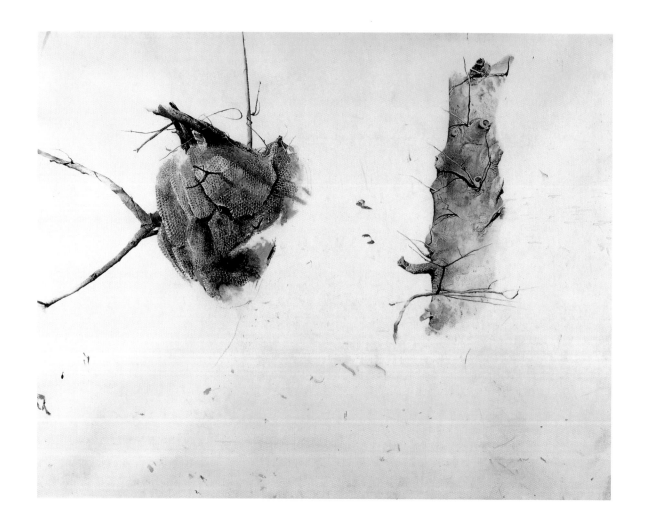

89. WINTER BEES, 1959
Drybrush

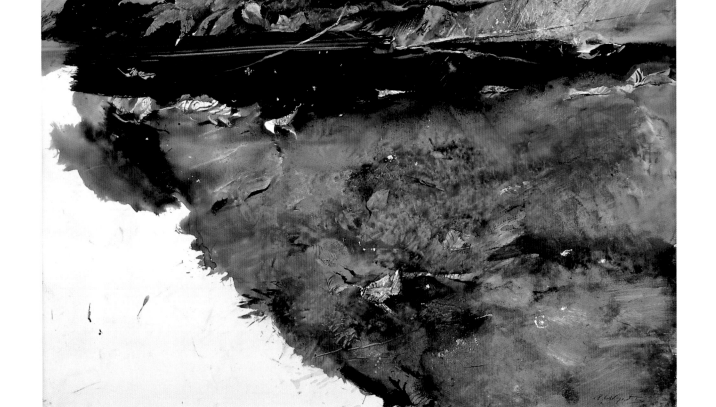

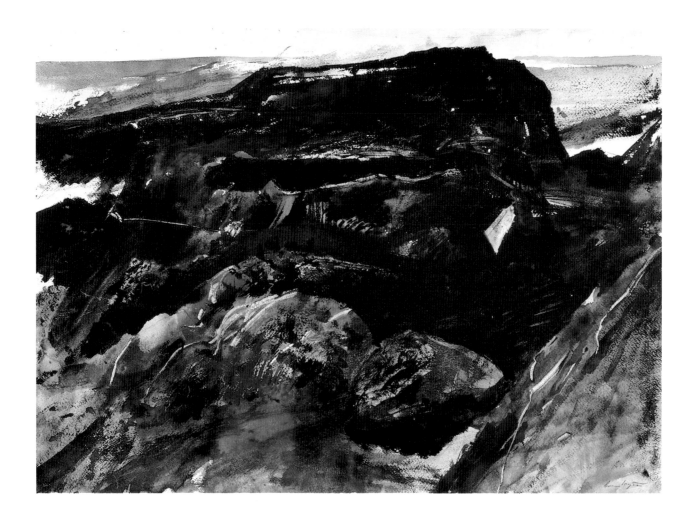

92. UNTITLED, 1950
Watercolor

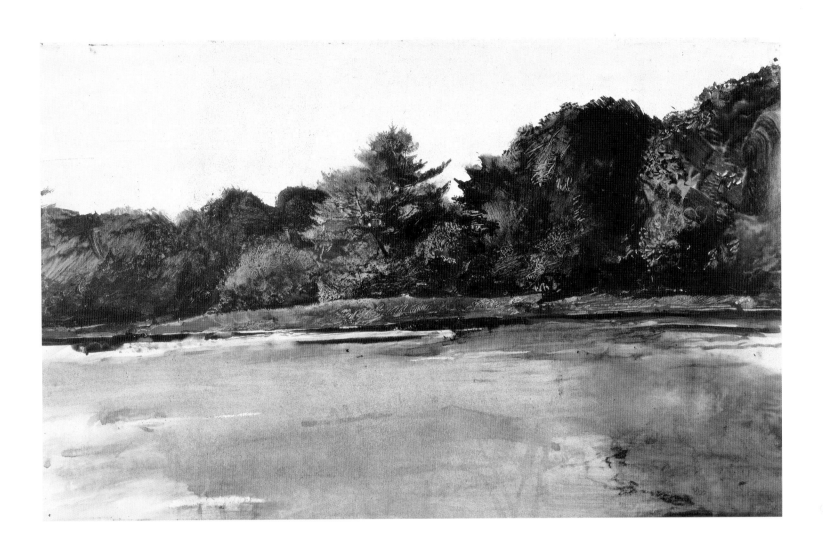

93. RIVER PINE, 1958
Watercolor

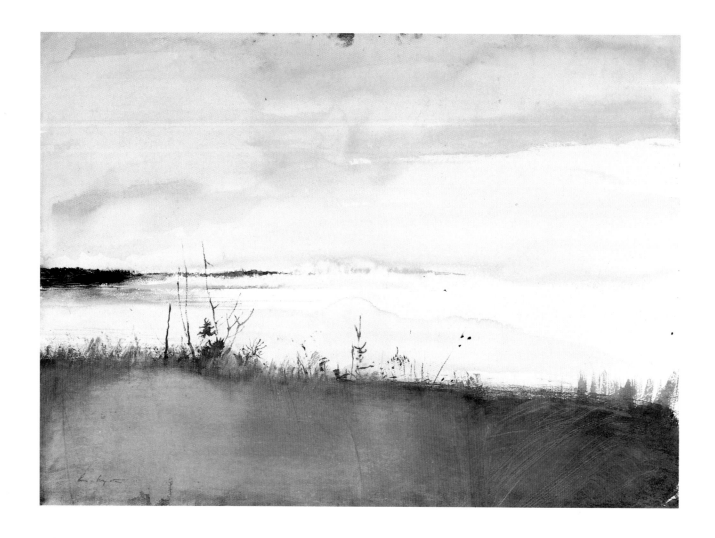

116

94. UNTITLED, 1961
 Watercolor

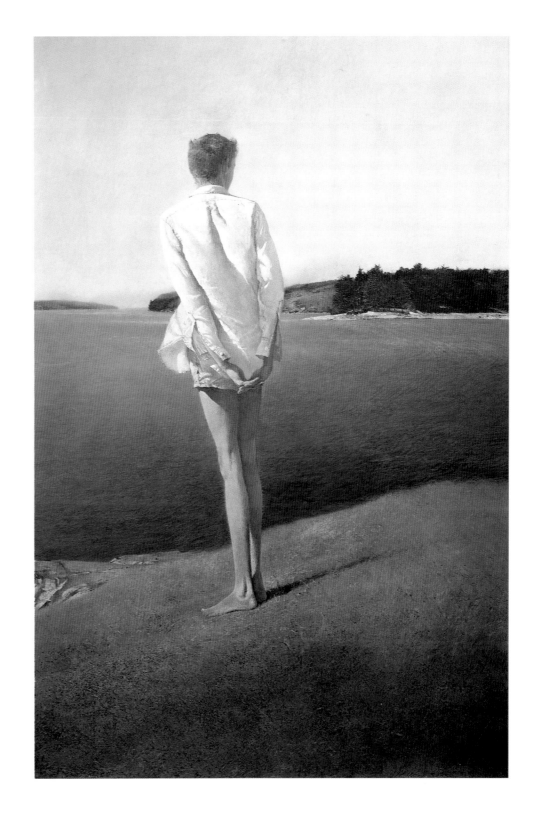

95. ABOVE THE NARROWS, 1960
Tempera

118

96. LIME BANKS, 1962
Tempera

97. LIME BANKS STUDY, 1962
Watercolor

120

98. UNTITLED (Study for BROWN SWISS), 1957
 Watercolor

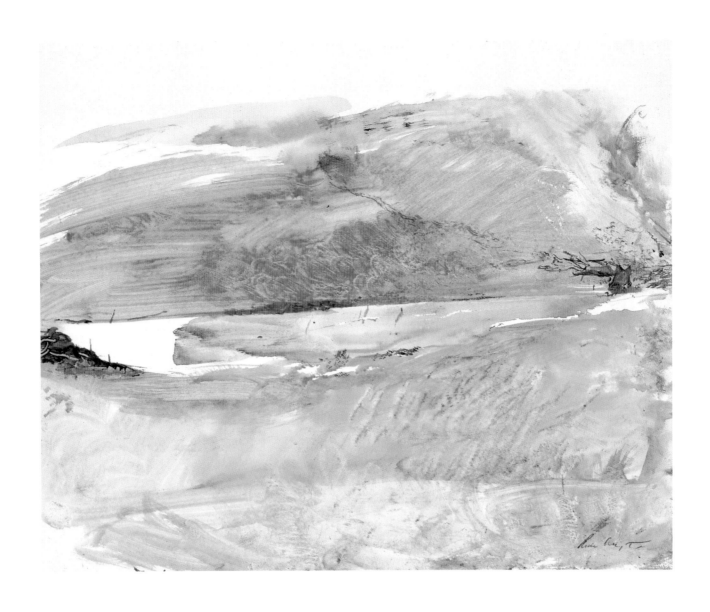

121

99. UNTITLED (Study for BROWN SWISS), 1957
Watercolor

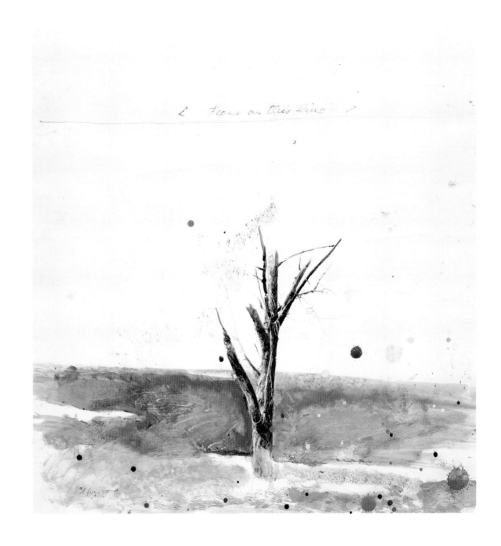

100. UNTITLED (TENANT FARMER STUDY), 1961
Watercolor

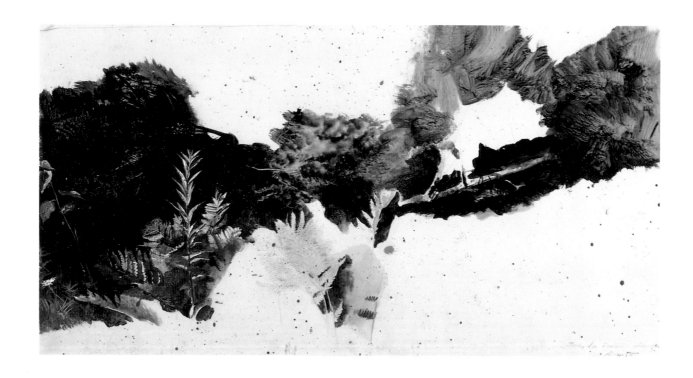

101. DISTANT THUNDER STUDY, 1961
 Watercolor

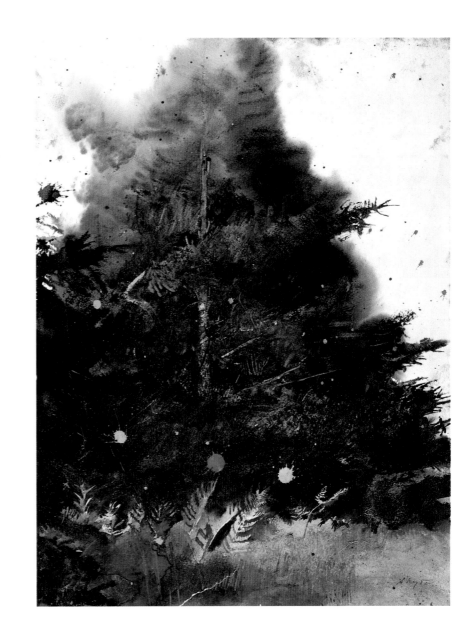

102. UNTITLED (DISTANT THUNDER STUDY), 1961
Watercolor

103. TENANT FARMER, 1961
 Tempera

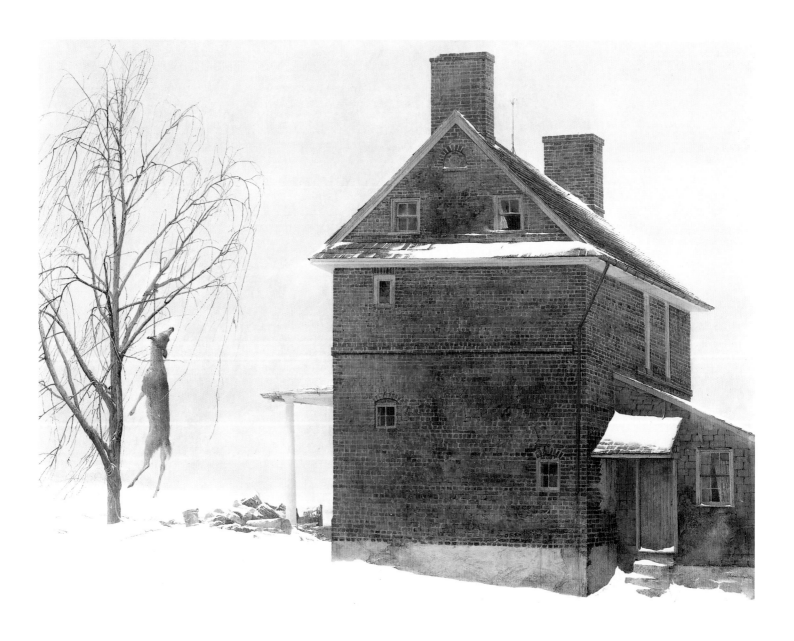

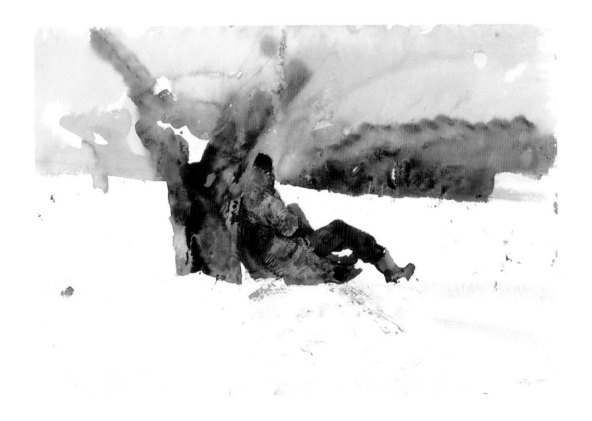

127

104. UNTITLED (ARMY SURPLUS STUDY), 1966
Watercolor

128

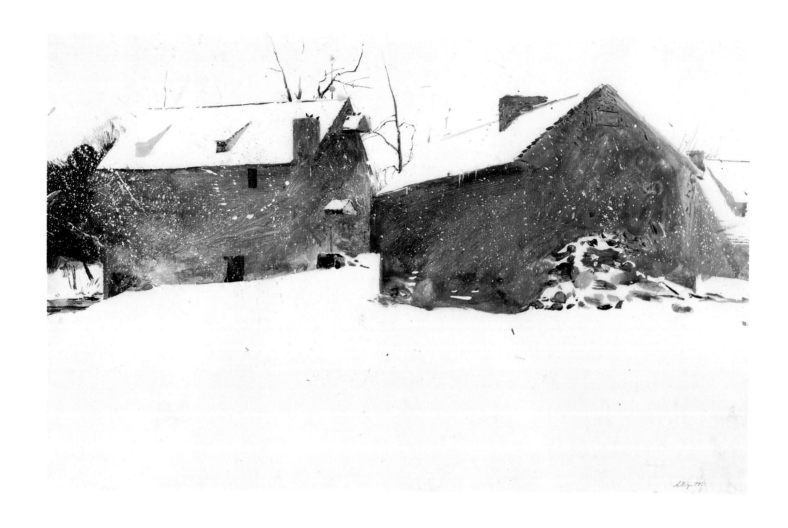

105. THE GRANARY, 1961
 Watercolor

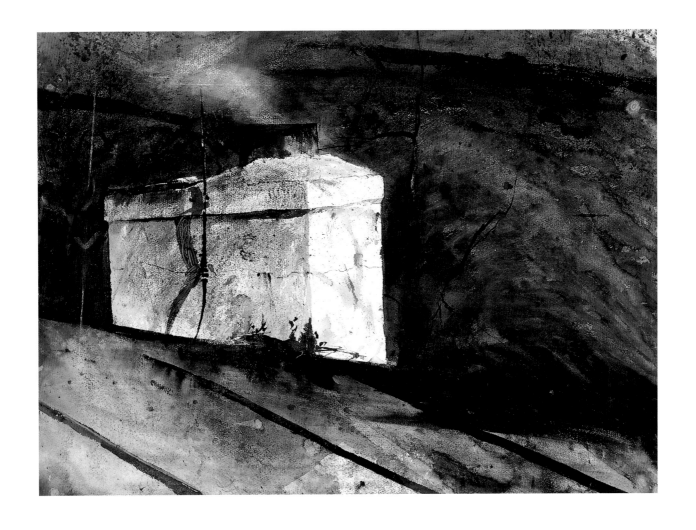

106. CHIMNEY SMOKE, 1957
Watercolor

130

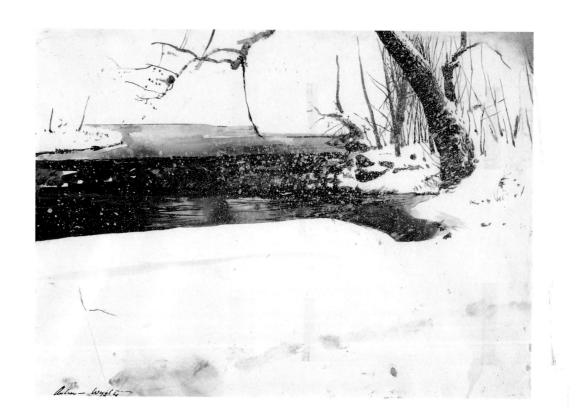

107. THE DAM, 1960
Watercolor

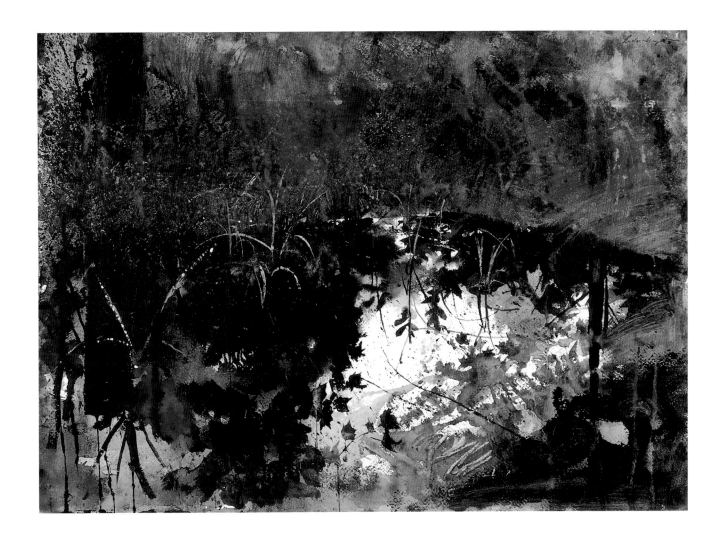

108. UNTITLED, 1962
Watercolor

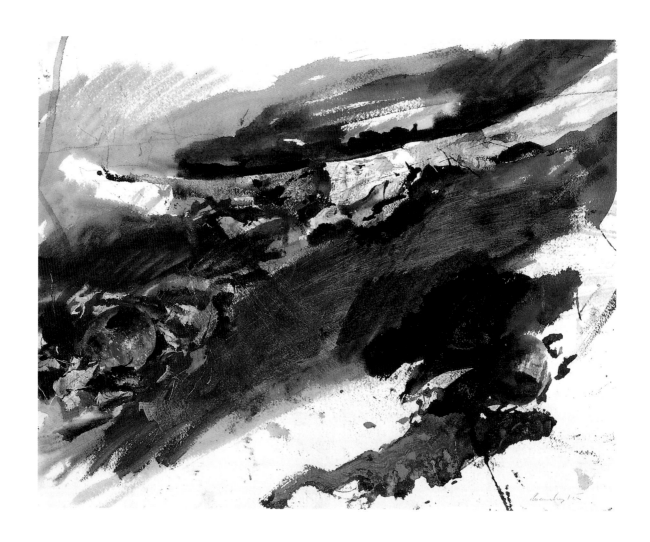

134

109. CIDER APPLES, 1963
 Watercolor

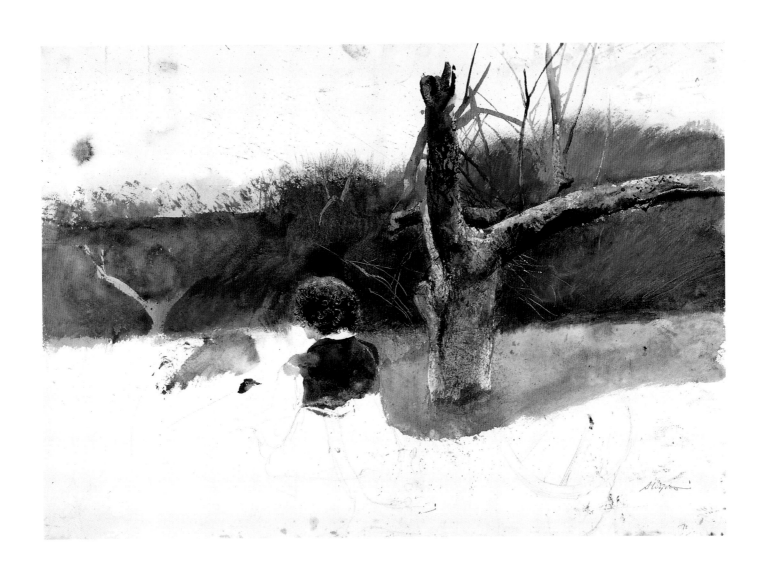

110. CAROLYN WYETH, 1963
Watercolor and graphite

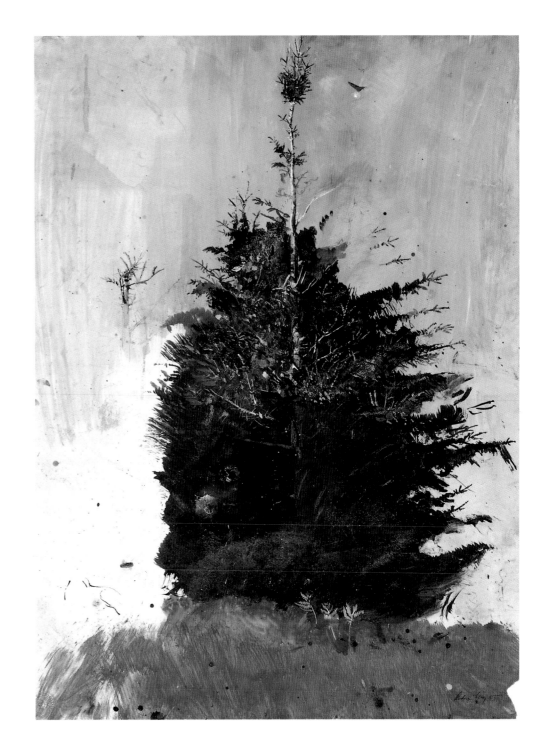

111. UNTITLED (DISTANT THUNDER STUDY), 1961
Watercolor

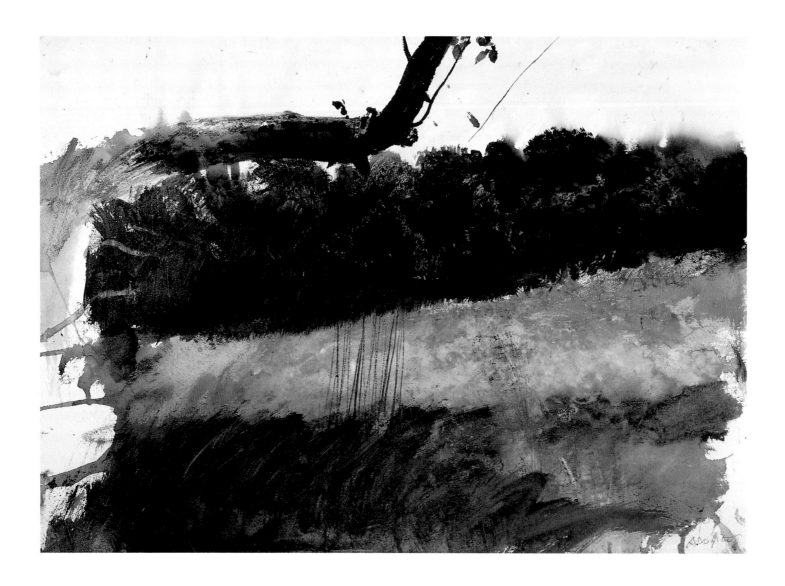

112. UNTITLED, 1963
 Watercolor

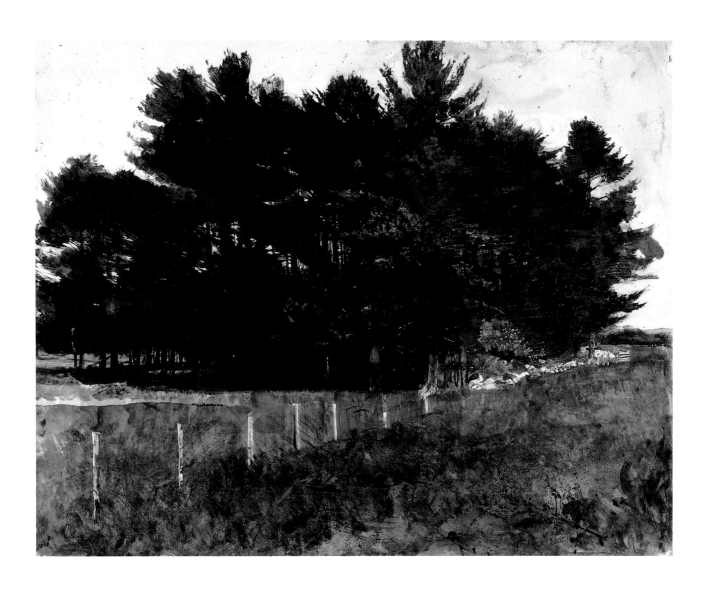

113. UNTITLED, 1953
Watercolor

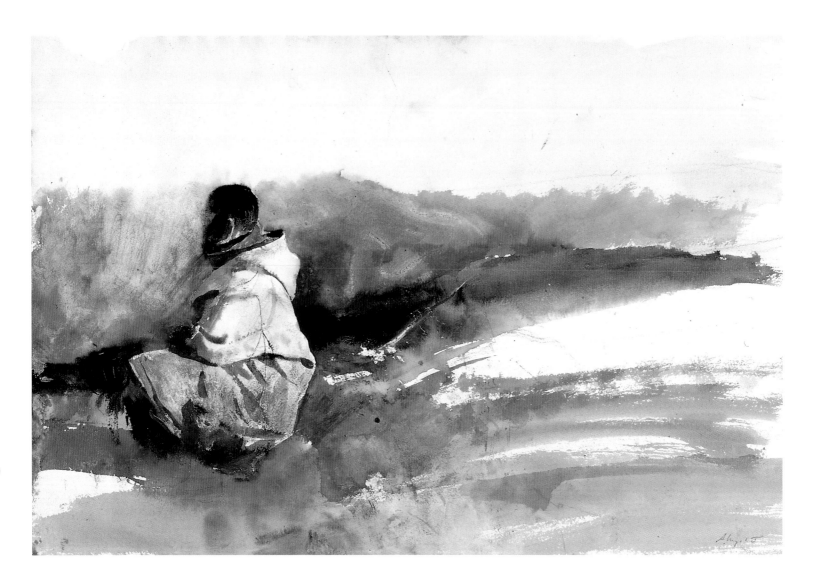

114. UNTITLED, 1966
 Watercolor

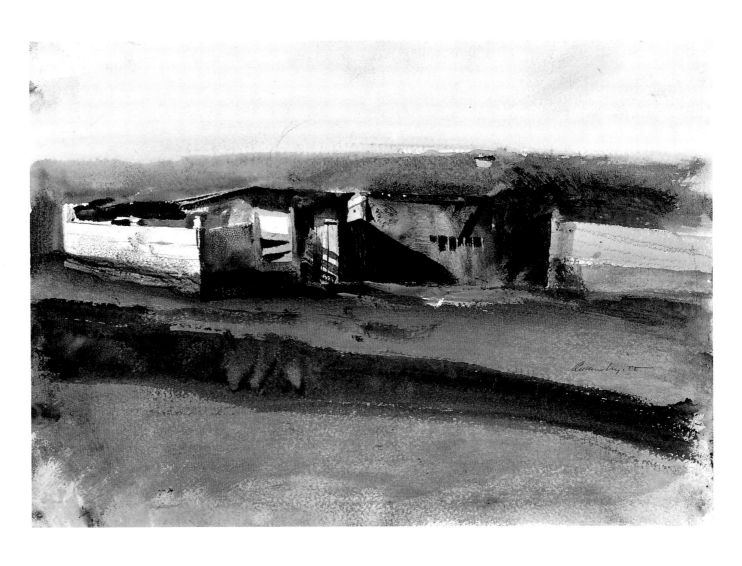

115. UNTITLED, 1955
Watercolor

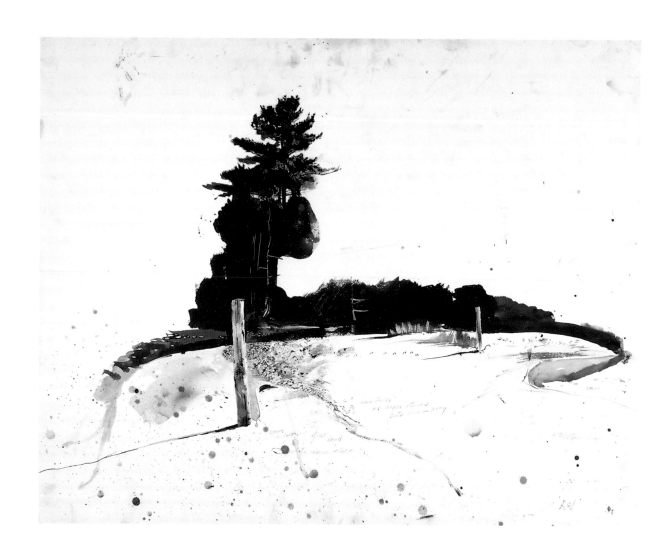

116. UNTITLED (SANDSPIT STUDY), 1953
 Watercolor

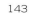

143

117. FIRST SNOW (GROUNDHOG DAY STUDY), 1959
Drybrush

120. RIVER VALLEY, 1966
Watercolor

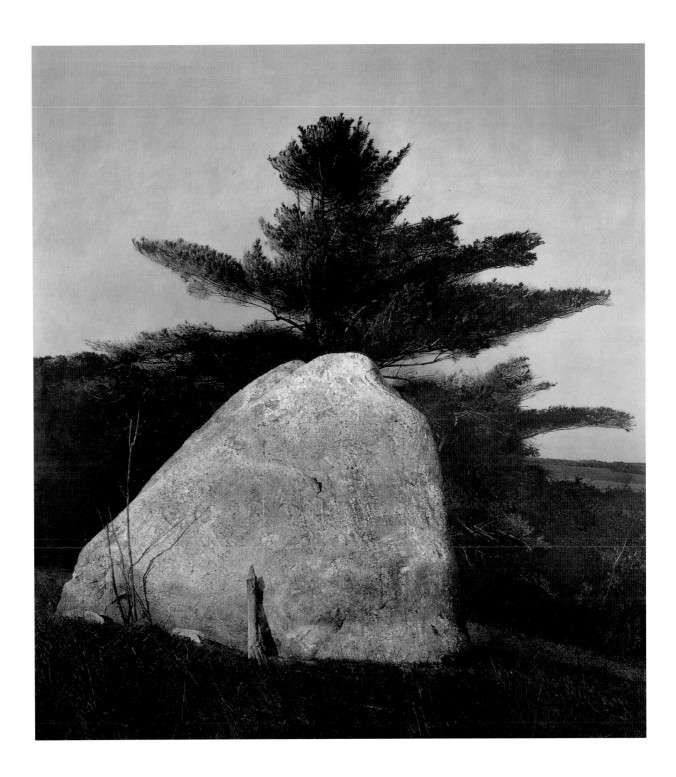

121. FAR FROM NEEDHAM, 1966
Tempera

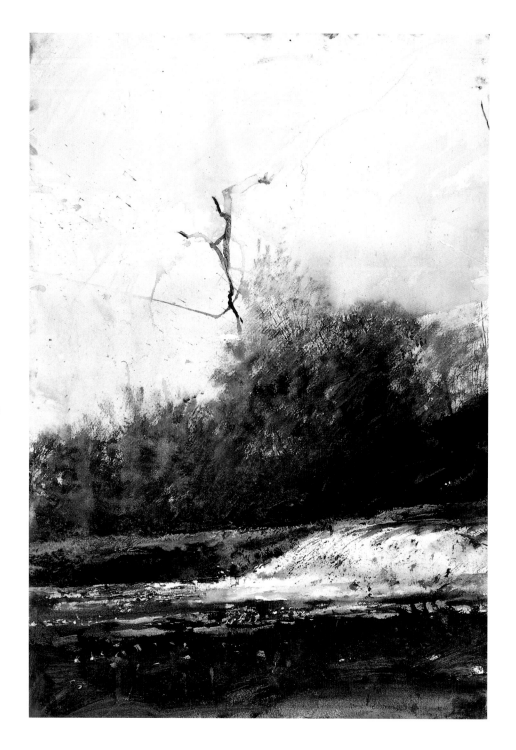

122. UNTITLED, 1962
Watercolor

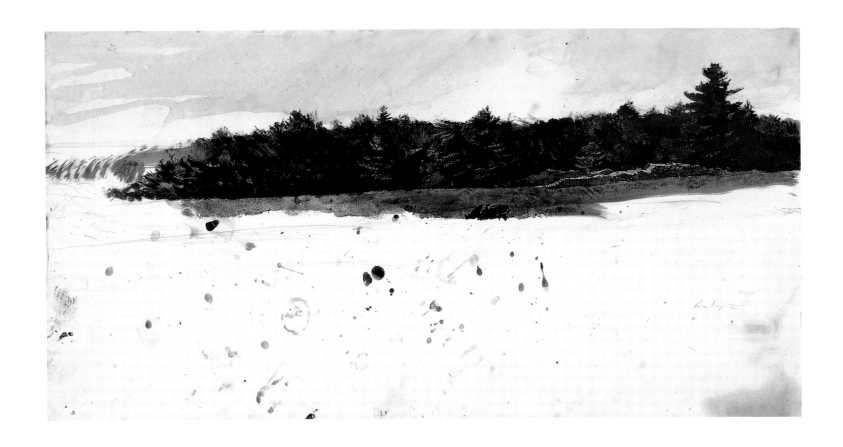

151

123. PULP WOOD, 1964
Drybrush and watercolor

152

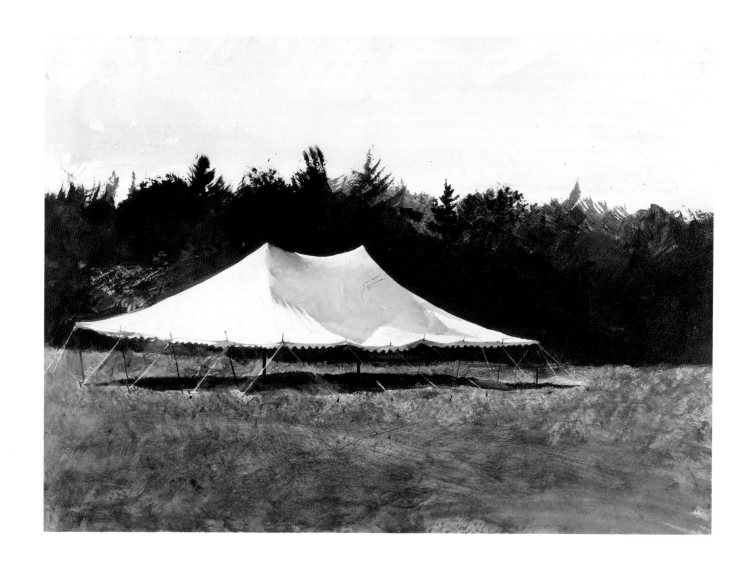

124. COUNTRY WEDDING, 1970
 Watercolor

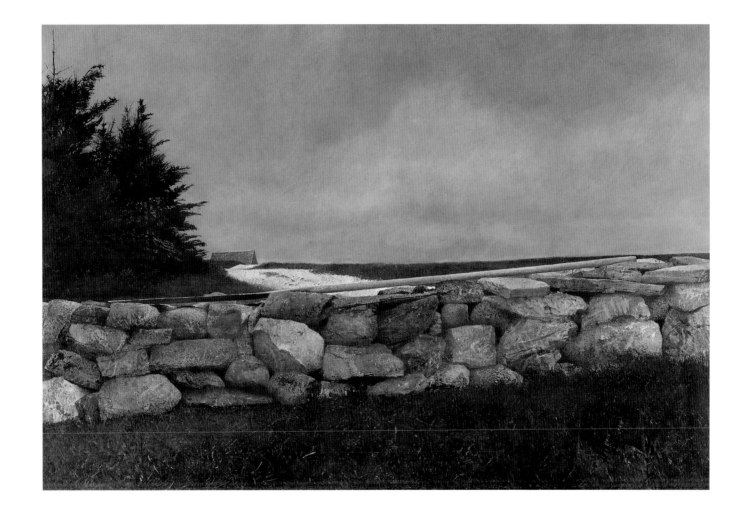

125. THE SWEEP, 1967
Tempera

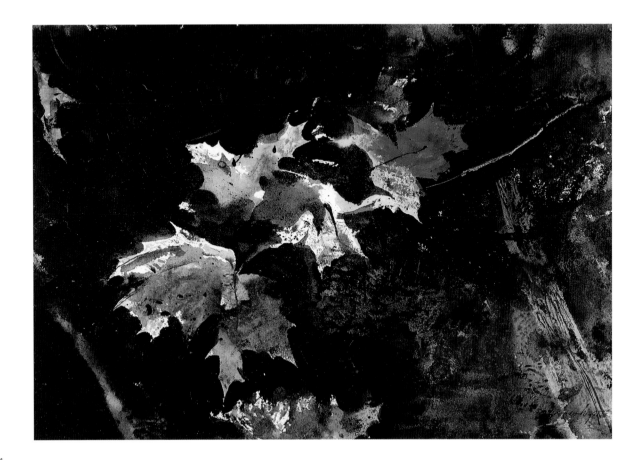

154

126. MAPLE LEAVES, 1979
 Watercolor

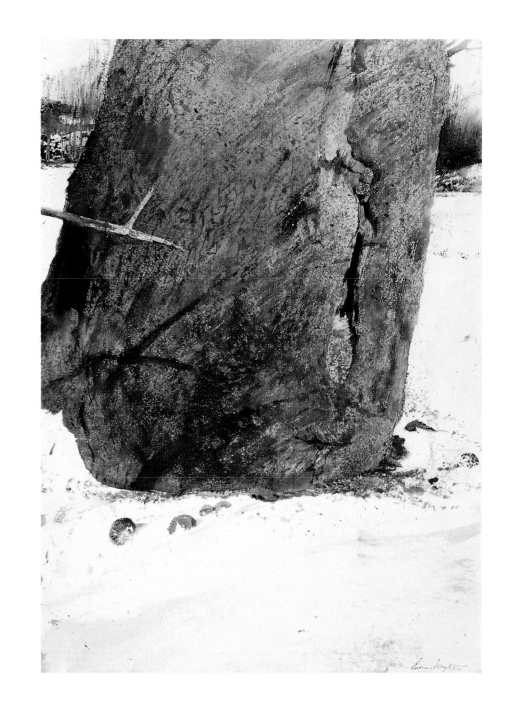

155

127. UNTITLED, 1969
Watercolor

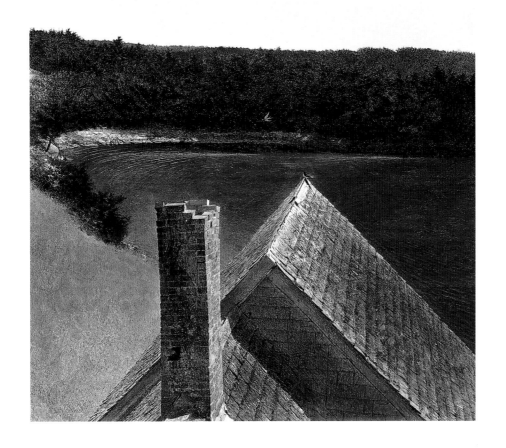

128. END OF OLSONS, 1969
Tempera

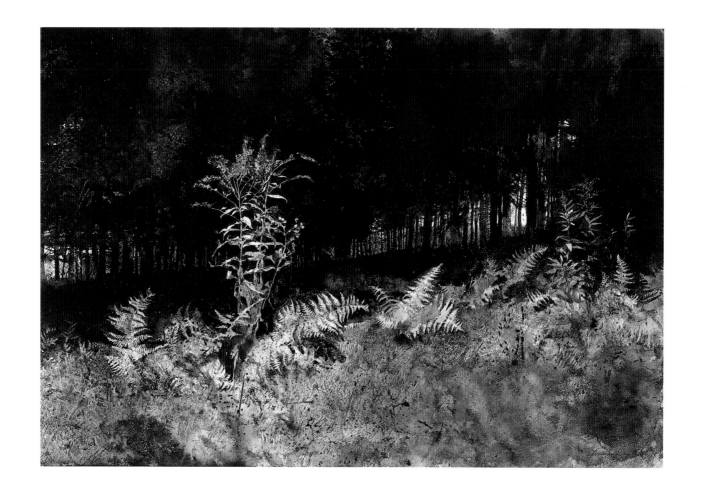

129. SPRUCE GROVE, 1970
 Watercolor

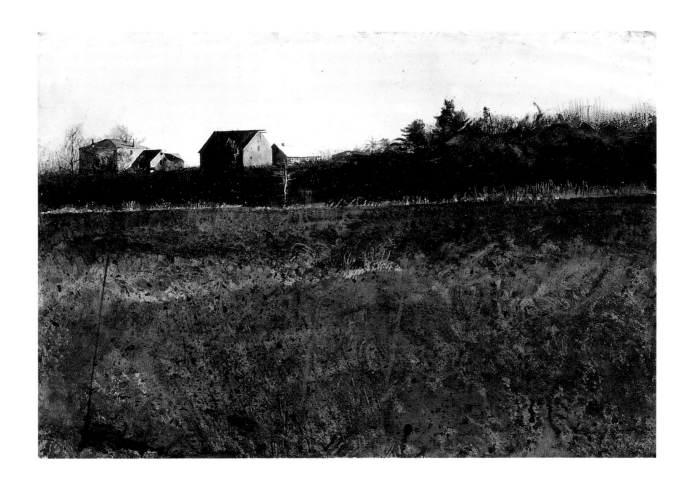

130. LAAKA FARM, 1970
Watercolor

162

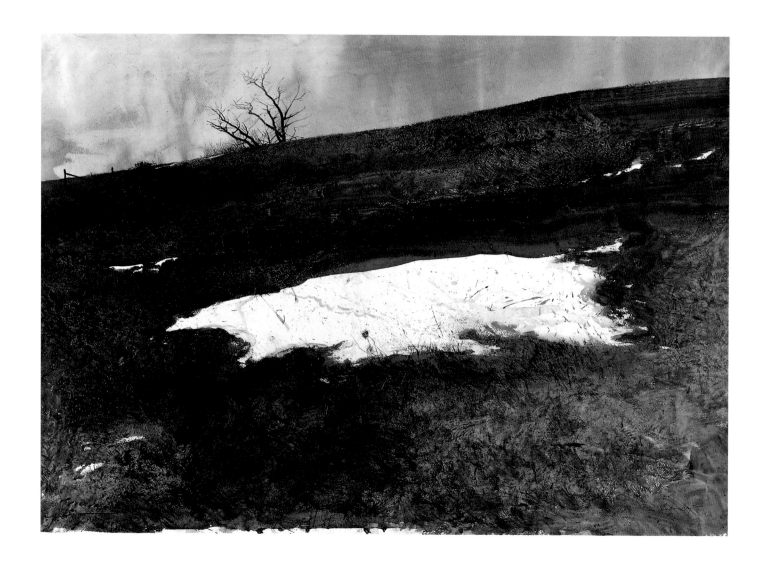

133. DOWN HILL, 1971
　　Watercolor

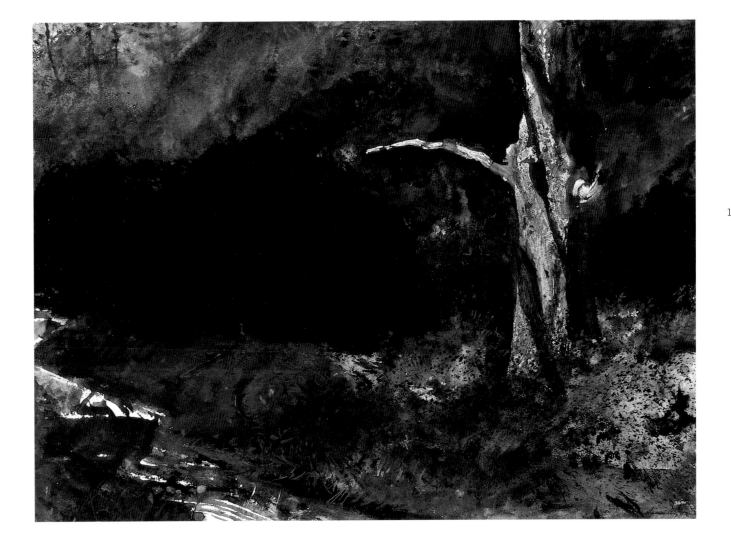

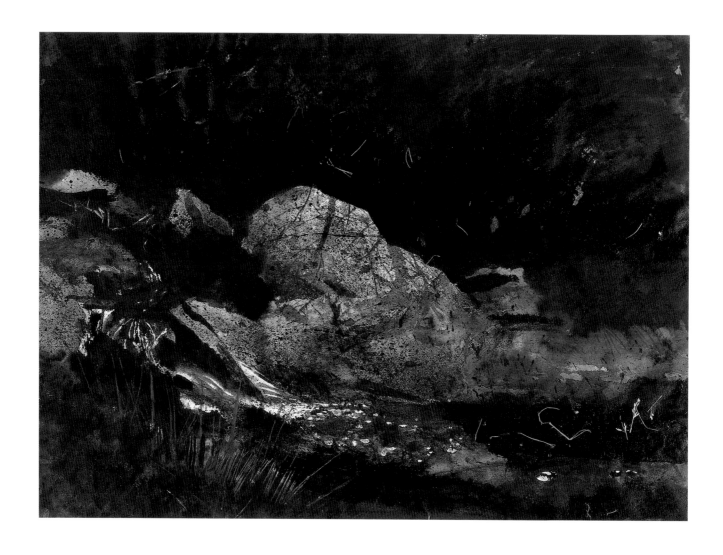

135. EASTMAN'S BROOK, 1971
 Watercolor

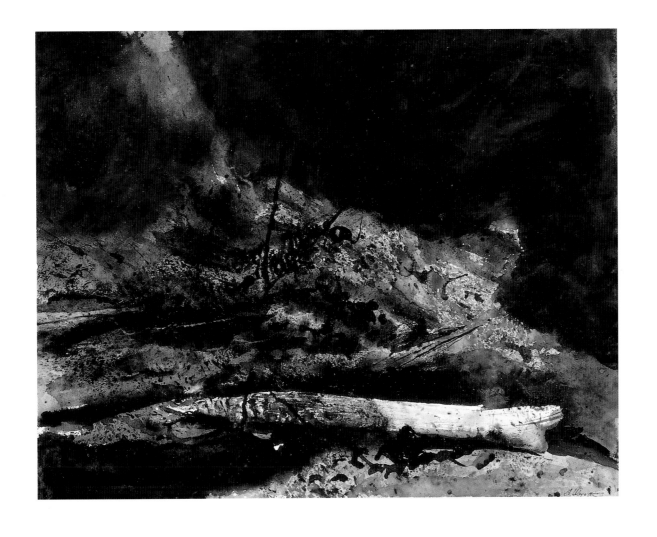

136. UNTITLED, 1974
Watercolor

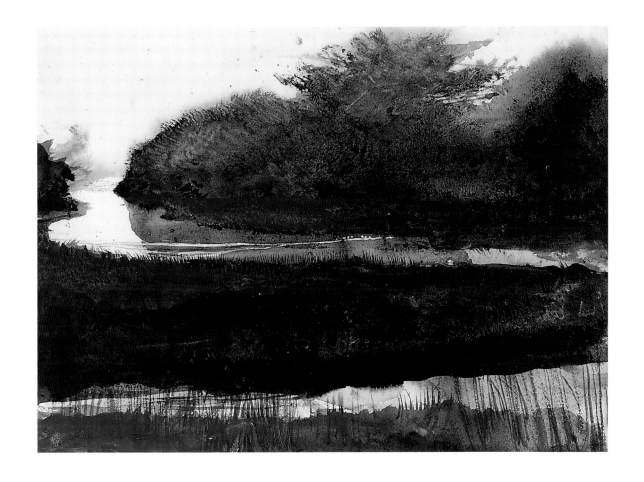

139. BACKWATER (STUDY), 1982
Watercolor

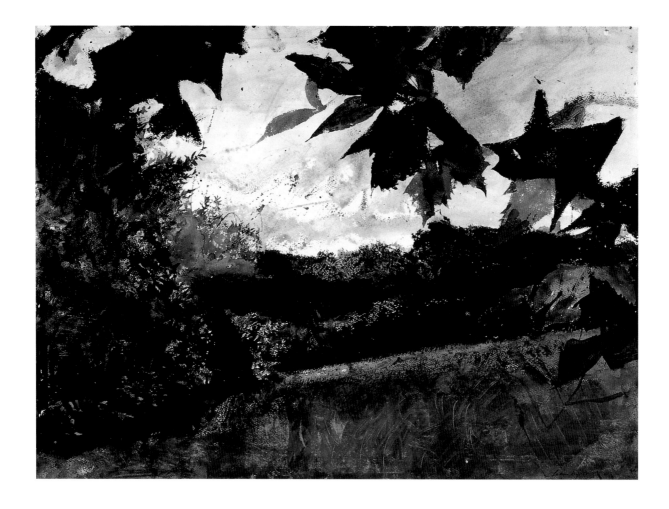

140. UNTITLED, 1978
Watercolor

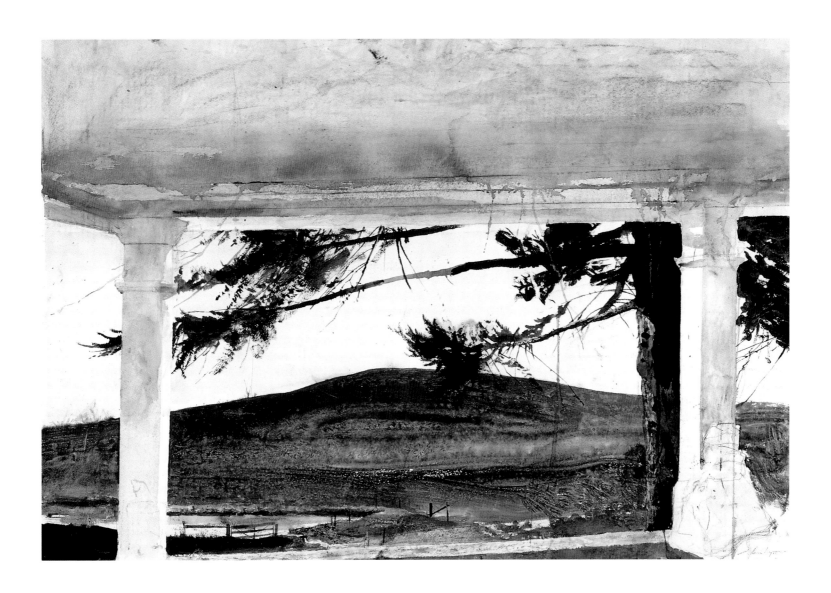

141. UNTITLED (Study for EASTER SUNDAY), 1975
Watercolor

174

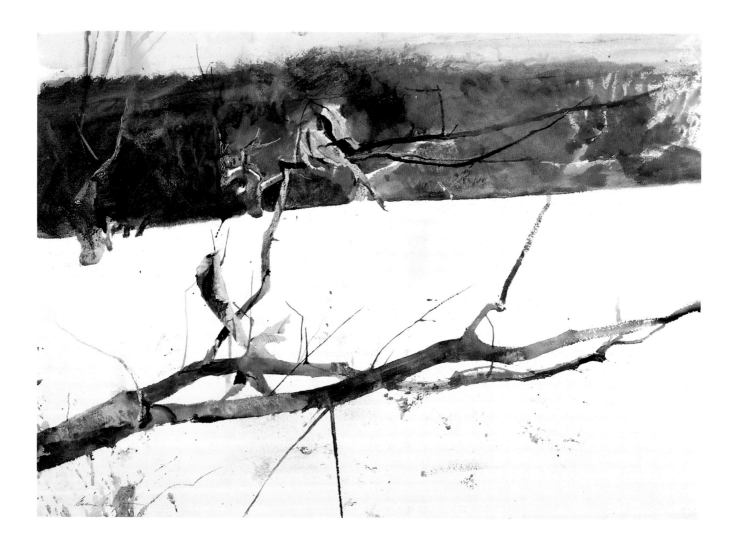

142. UNTITLED, 1980
 Watercolor

143. BUTTONWOOD LEAF, 1981
Drybrush

144. SYCAMORE, 1982
Watercolor and drybrush

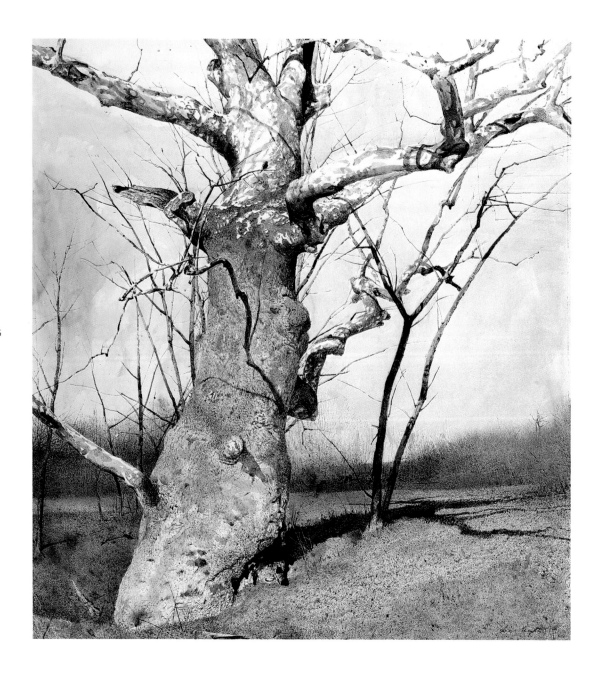

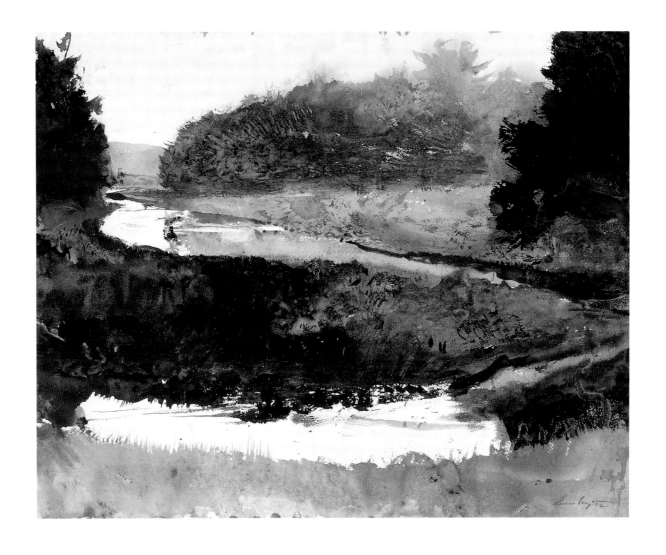

145. UNTITLED (BACKWATER STUDY), 1982
Watercolor

146. TREE HOUSE, 1982
Watercolor and drybrush

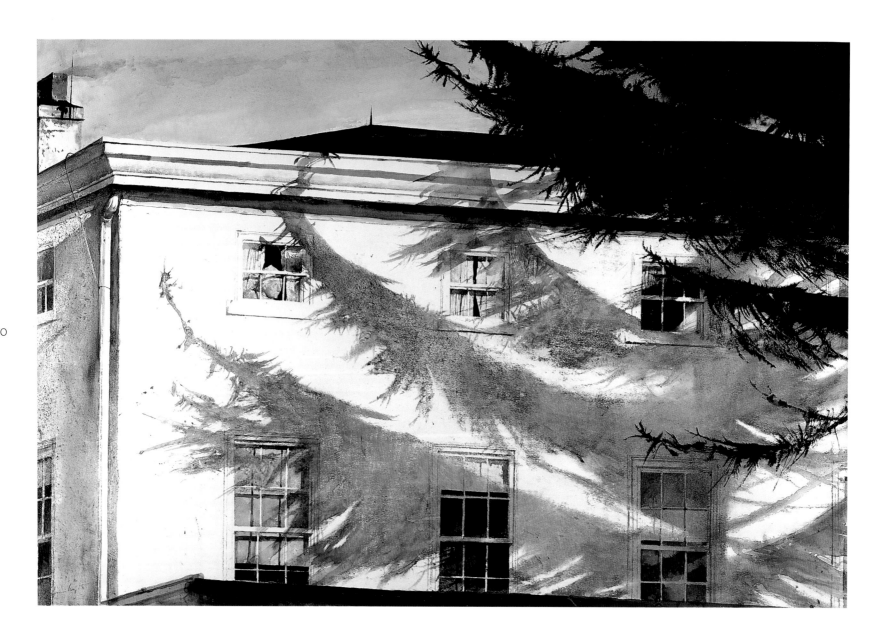

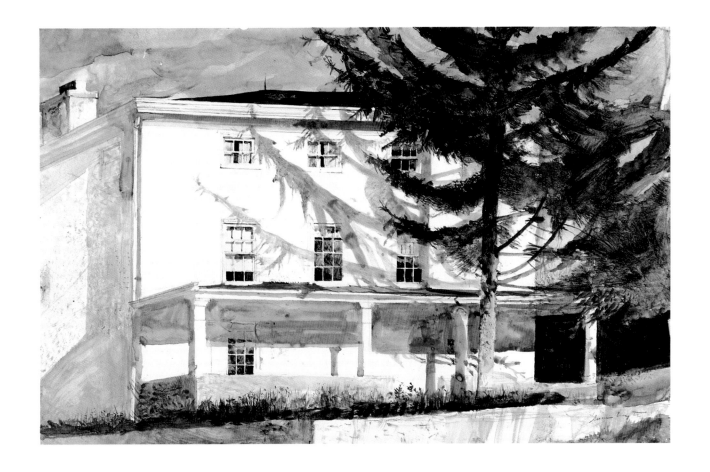

147. UNTITLED (TREE HOUSE STUDY), 1982
Watercolor, drybrush, and graphite

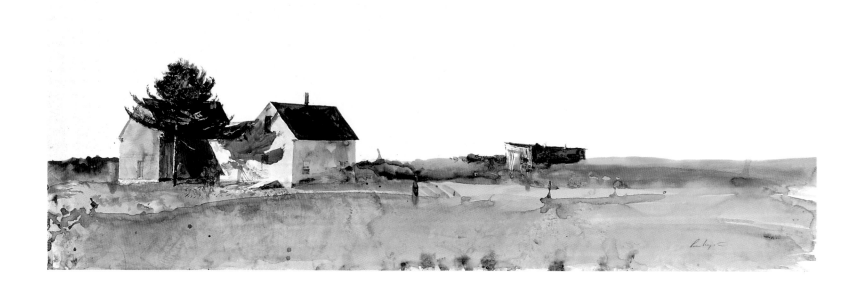

148. UNTITLED, 1985
 Watercolor

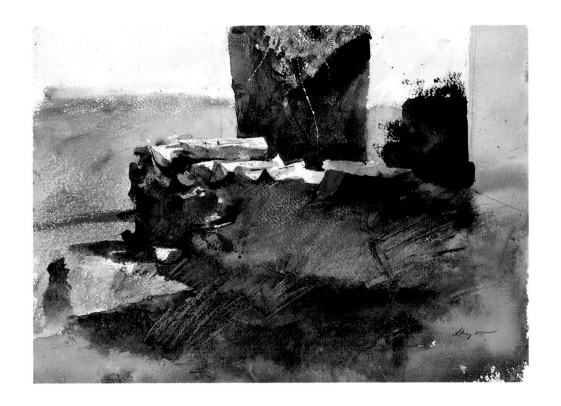

149. UNTITLED (WOODCHOPPER STUDY), 1964
Watercolor

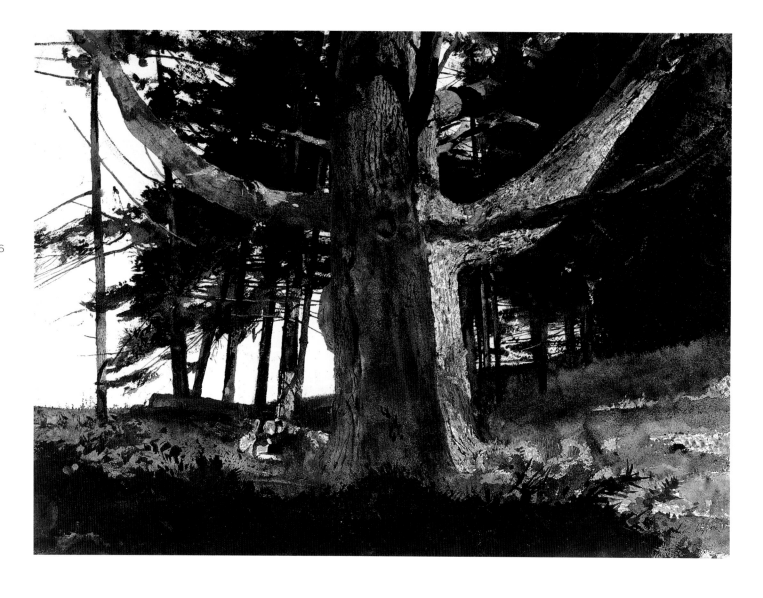

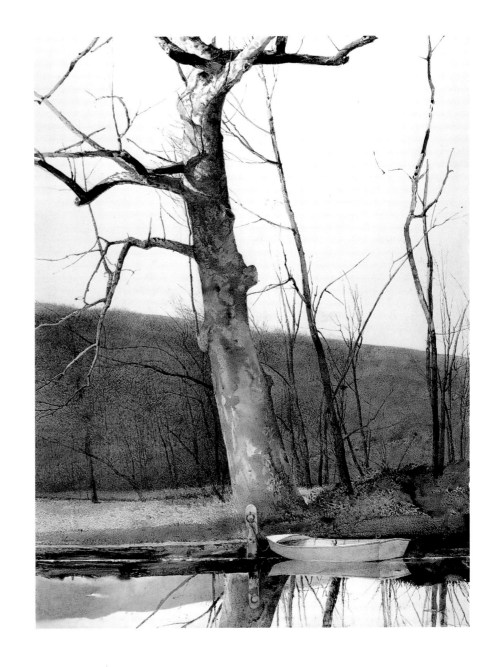

153. COLD SPRING, 1988
Drybrush

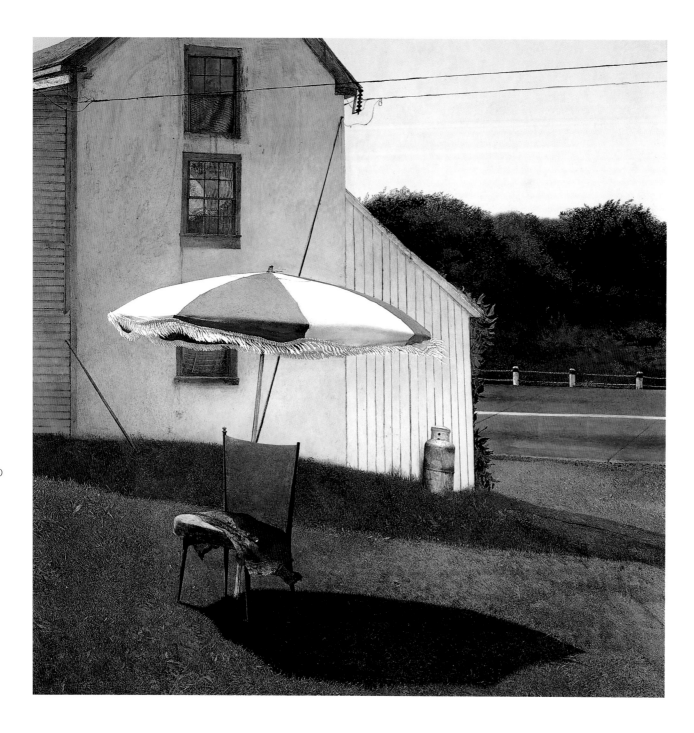

154. OLIVER'S CAP, 1981
Tempera

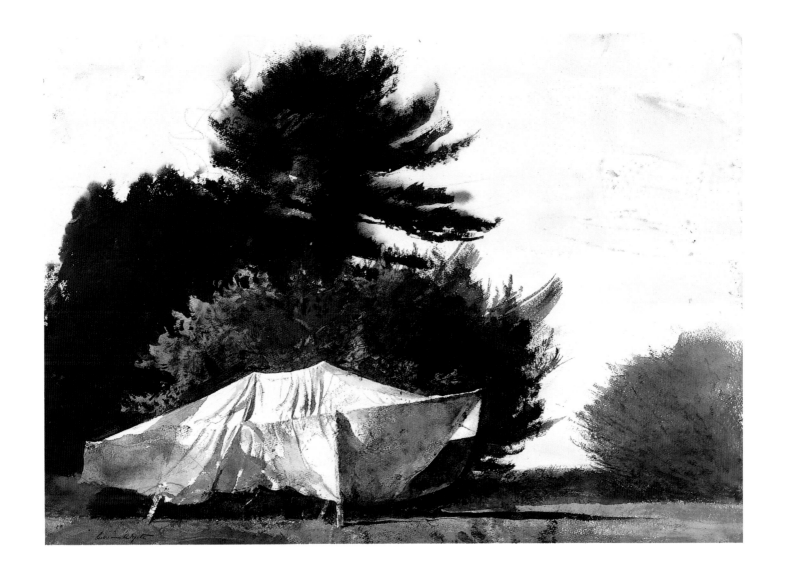

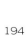

158. RING ROAD, 1985
 Tempera

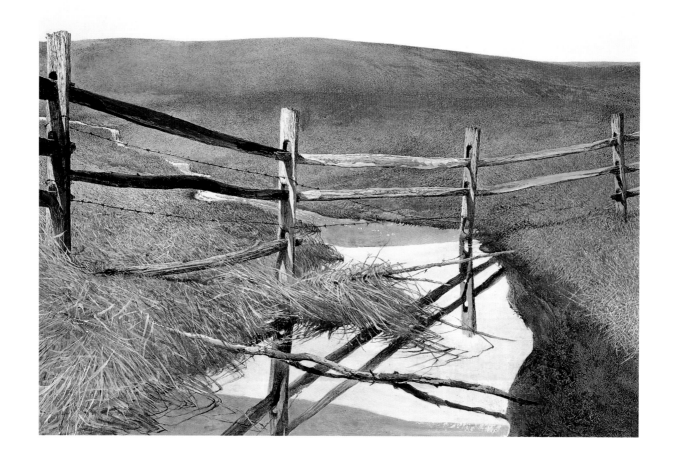

196

160. RUN OFF, 1991
Tempera

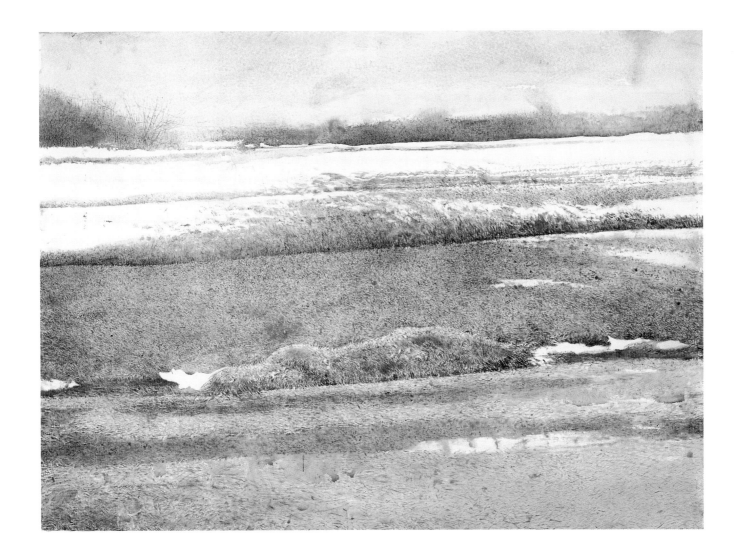

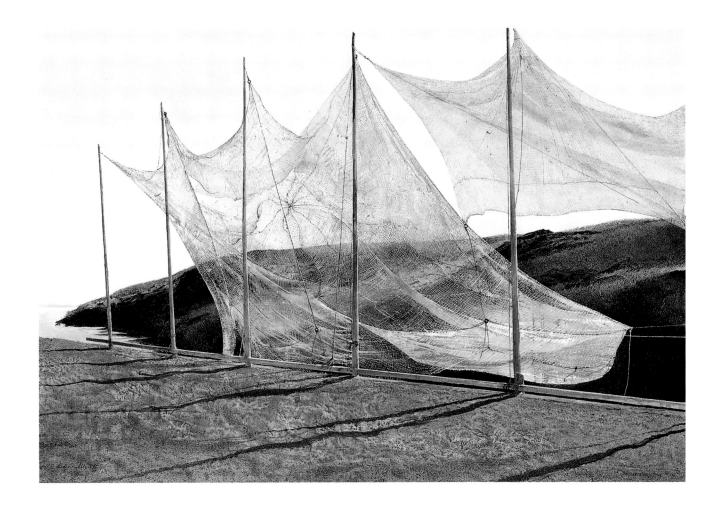

162. PENTECOST, 1989
Tempera

I was in an upstairs room in the Olson house and saw Christina crawling in the field.

Later, I went down on the road and made a pencil drawing of the house, but I never went

down into the field. You see, my memory was more of a reality than the thing itself.

I didn't put Christina in till the very end. I worked on the hill for months, that brown

grass, and kept thinking about her....[3]

More recently, in 1997, Wyeth remarked, "If I was really good, I could have done the field in CHRISTINA'S WORLD without her in there. The less you have in a picture, the better the picture is, really."[4]

One of Wyeth's most characteristic qualities, in fact, is his fondness for the absence of a presence. In ROPE AND CHAINS (Study for BROWN SWISS) (1956; Fig. 75), whose subject is the slaughter of pigs, only the instruments of death are present, not the victims. In BROWN SWISS (1957; Fig. 82), we do not see the cattle, only their tracks. About WOODCHOPPER (1964), Wyeth explained: "I think, very strongly, it's what's *not* there that's important." In ALVARO AND CHRISTINA [Olson] (1968), painted a year following their deaths, the two figures are represented by adjacent doors: one bleak, shadowy, and brown, the other brightly blue and sunlit. About TRAMP IN THE BARN (1978), a hushed snowscape, the big red door slightly ajar, Wyeth wanted to "express the power of what could have been in there and what was not there any longer." In SQUALL (1986), we see a seascape through a kitchen window, but the focal point is Betsy Wyeth's bright yellow slicker hanging from a peg. "Betsy's no longer in the picture," her husband explained, "but she's still there."[5]

Wyeth is not a model of consistency, however, and we do encounter occasional dissonance amidst the patterns of resonance. Sometimes a situation or a mood may alter his

customary practice. Hence he wrote the following about WOOD STOVE (1962): "There's Christina sitting in the kitchen, on the left, and everything's in there—the stove, the geraniums, the buckets, and the trash. I had to overdo it here and reveal all the secrets. Some people say that artists ought to work for utter simplicity. I say to hell with that! Let's get it all in there. I'm afraid of editing too much; it's not natural to be simple and pure." "Great simplicity," Wyeth once remarked, "is complex."[6]

The differences between Andrew's art and that of his father are instructive here. N.C. Wyeth enjoyed great success as an illustrator because of the energetic drama in his pictures. Andrew's landscapes, by contrast, are characterized by expectant drama. N.C. Wyeth portrayed explicit action, whereas Andrew offers implicit anticipation and tension. The responses written in a comment book by visitors to an Andrew Wyeth exhibition in Kansas City during the autumn of 1995 suggest that, for many viewers, it is Wyeth's dissonances that resonate. They perceive him to be an artist of simultaneous opposites, painting "emphasis through nonemphasis," so "simple and complex," a "mixture of joy and pain." Some people reported that they wept: "tears and warmth all at the same time." Still others saw "darkness with hope."[7]

Art historian Brian O'Doherty is absolutely on target when he refers to the "desolate tenderness" and "latent violence" in Wyeth's work.[8] Nevertheless, despite the differences between them, we must never ignore the profound influence of N.C. Wyeth on his son. Listen to passages from a letter from father (teacher) to son (former student) written in 1944:

This week has been, to me, a singular mixture of ineffable sadness and inspiration—
two moods that often happen together....Periods of bleak thinking and austere feeling, that
*kind that cuts to the bone, are imperative....*Intensity, distinction, fire—*those elements*
of mature sincerity....[9]

Andrew's art is very different from his father's, but his temperament is not. His debt to his father, which he has always acknowledged, is genuine. "Intensity" is key. Whenever Andrew describes a moment of great inspiration, an artistic epiphany, the phrase that he invariably utters is "my hair went on end." He acknowledges in retrospect that "somber feeling was my strength." His characteristic colors—creamy white, dun, ocher, black, a small touch of blue or Indian red—convey his sense of the earth in late fall and winter, the seasons he loves best.[10]

The elements Andrew has added to his father's homily—dogged individualism, "free spirit," and "cutting [through] the grease," as he so often puts it—begin to explain the enormous appeal of his art.[11] But there is much more, for his resonance with the general public is as multifaceted as his dissonance with so many art critics and fellow artists who are modernists or postmodernists of one kind or another. I suspect that, more often than not, Wyeth receives disapproval from "serious critics" and effusive appreciation from his (by now) international fans for equally inappropriate reasons. He is considerably more serious, sincere, and complicated than the former are prepared to recognize, yet a lot less accessible and comprehensible than the latter realize. Just because an artist is identified as a "realist" does not mean that his subject or his actual intentions are self-evident or self-explanatory. We should take Wyeth's words on this point at face value.

Oftentimes people will like a picture I paint because it's maybe the sun hitting on the side of a window and they can enjoy it purely for itself. It reminds them of some afternoon. But for me, behind that picture could be a night of moonlight when I've been in some house in Maine, a night of some terrible tension, or I had this strange mood. Maybe it was Halloween. It's all there, hiding behind the realistic side.[12]

Wyeth's work has been described very aptly by a British observer as "serious popular painting."[13] His remarkable success with the general public from the very start of his career during the forties and fifties is only partly explained by his representational realism, which must have seemed a welcome relief from Abstract Expressionism and subsequent "isms" that typically evoked such responses as "my five-year-old could do that." We must also take into account the cold war atmosphere of the era and remember that Wyeth appealed to many because he seemed neither bohemian nor politically to the left. Indeed, his comments on the overall content and implications of his work have always had a chauvinistic tone. As he said in 1965: "America's absolutely it....It's the quality of the early weather vanes, the hinges on the doors. It's very hard to pinpoint. THE PATRIOT (Fig. 163)—there's a certain awkward, primitive quality in that portrait I feel could only have been done by an American. It's sort of dry, for one thing. Robert Frost's best poetry has a dry quality." Thirty-two years later, in July 1997, he reiterated those sentiments in a nationally televised interview: "Nothing I've cherished more than being an American and trying—and I say trying—to express the real power of what America stands for. Freedom—not being tied to any methods. Open expression. I thank the American climate—the openness, the bigness of it."[14]

163. THE PATRIOT, 1964
Tempera on panel, 28 x 24 (71.1 x 61)
Collection of Andrew and Betsy Wyeth

That attitude was clearly conveyed in a Wyeth icon that attracted considerable attention in 1951, the figurative landscape titled YOUNG AMERICA (Fig. 164), an engaging statement of youthful energy and freedom in a boundless terrain just waiting to be known. For a feature essay in TIME on his new work, Wyeth explained:

> I was struck by the freedom [the bicycle rider] represented—by distances in this country, the plains of the Little Bighorn and Custer and Daniel Boone and a lot of other things. I was excited by the motion of the bicycle too. [The faux fox-tail streaming from the handle-bar is delicately painted red, white, and blue!] The moving wheels were one of the most difficult things I ever painted. I called it YOUNG AMERICA because it expressed in a way the vastness of America and American history.[15]

Wyeth's painting anticipated by a few years the James Dean movies *Rebel Without a Cause* and *East of Eden*, both released in 1955. It also built upon a venerable tradition, a veritable mythos, of the United States as a young but energetic and vibrant nation. One thinks of James McNeill Whistler's ARRANGEMENT IN WHITE AND BLACK: THE YOUNG AMERICAN (c. 1878) and Gabriel Harrison's popular daguerreotype of his son, which he too called YOUNG AMERICA (1853; Fig. 165), an image intended to be patriotic in its symbolism. Oscar Wilde, in one of his more inspired ironies, quipped that "the youth of America is their oldest tradition."[16]

The importance of Wyeth's "Americanness" to many of his admirers cannot be overestimated. Exhibition catalogues and essays make a point of his ancestry: that Nicholas Wyeth

164. YOUNG AMERICA, 1950
Tempera on board, 32½ x 45⅝ (82.6 x 115.1)
Pennsylvania Academy of the Fine Arts, Philadelphia; Joseph E. Temple Fund

Gabriel Harrison
165. YOUNG AMERICA, 1853
½ plate daguerreotype, 4¼ x 2½ (10.8 x 6.4)
George Eastman House, Rochester, New York

emigrated from England to Cambridge, Massachusetts, in 1645, and that Wyeths died fighting in the French and Indian War. We are not offered genealogies of Joseph Stella or Ben Shahn or Willem de Kooning. How "American" they are seems inconsequential. And with the passage of time Wyeth's infrequent, casual, seemingly innocuous comments in the political sphere only cause ripples on the left and leave the rest of his admirers unperturbed or else pleased: his praise for Richard Nixon in 1970, his vote for Ronald Reagan in 1980, and his curiously opaque explanation of a beautiful 1993 painting he titled THE LIBERAL (Fig. 166)—"This is a young lady who works for me at Chadds Ford. Interesting sort. I'm not sure what to make of her. Intelligent....Quick. Will snap right back at you....She's a liberal—politically—and she sat there completely within herself, just like a liberal."[17]

To most observers, Wyeth appears to be an apolitical man, an artist of consensus more concerned with serene or sad beauty than with social or ideological conflict. His celebration of his terrain—his affection for America—has a much more particular character, however, which is epitomized by a phrase developed by our most distinguished historical geographer, Yi-Fu Tuan. Tuan's phrase is "geopiety," and it refers to our sense of attachment to nature and to place. Precisely because so many Americans have not actually had or acted upon such an attachment, preferring the socio-economic advantages of mobility, they develop nostalgia for images of geopiety and the conscientious creators of such images. As Tuan has pointed out, an intense attachment to the place of one's birth and a rootedness in the soil have been much less common in the latter half of the twentieth century than in earlier ages. Moreover, "the form of geopiety called patriotism is easily distorted by abstractions. From an attachment to place based on intimate knowledge and memories [both of which Wyeth has in abundance], it is a short step to pride of empire or national state that is no part of one's direct experience."[18]

207

166. THE LIBERAL, 1993
Drybrush and watercolor on paper, 16¾ x 23⅛ (42.5 x 58.7)
Private collection

I find it significant that when Wyeth's admirers articulate the reasons for their affinity with his work, they commonly cite their strong feelings for the particularity of place. One letter writer declared: "When I read about the 'Helga' works, I wanted to see those landscapes again. On that Saturday afternoon drive, I realized that this was my landscape, the place where my mind and heart lived in so many ways; it was a home that Andrew Wyeth had created for me." The writer concluded: "to pass Andrew Wyeth off as a mere draftsman is to discard the opportunity of residing in a landscape that is rife with energy and emotion."[23]

The resonance (and sometimes the dissonance) of Wyeth's landscapes owes a great deal to the variability of his vistas. Many of them have been sketched and painted with the artist peering through a window, often from quite an elevated level, such as the third floor of the Olson house in Cushing, Maine, or of the Kuerner house in Chadds Ford. Consequently, some of the terrains Wyeth presents to us as sprawling and infinite were actually framed and finite when he initially saw and recorded them. He decidedly has the gift of abolishing spatial constraints from the mind's eye in order to expose an emotion-laden expanse of boundlessness.[24]

With equal frequency, however, and with remarkable ingenuity, Wyeth will frame a far more modest landscape seen through some aperture (window or door) in the background of an interior scene. He does so in WIND FROM THE SEA (1947; Fig. 67), where the window is horizontal and the terrain prominent. He does so in SEED CORN (1948; Fig. 57), where the window is vertical and our vision of the exterior partially eclipsed. The terrain provides a centering equilibrium for two sets of corncobs drying inside. He does so in NIGHT SLEEPER, skillfully using two square windows to frame contrasting vistas of a barn and a

barren field bisected by a stream. And he does so with SQUALL (1986), showing us a lowering sky above white caps at sea.[25]

In one of Wyeth's best-known paintings, SPRING FED (1967), the right-hand window above the water trough, showing us cattle against the backdrop of a huge hill, achieves the same effect that Ralph Earl (1752-1801) managed so often in his portraits of prominent New Englanders late in the eighteenth century (Fig. 167). When Wyeth uses the time-honored Ralph Earl technique, he defines and controls very precisely the landscape that he wants to suggest. But Wyeth's use of the window is considerably more subtle than Earl's. The colonial artist wanted to combine portraiture with landscape, but also to flatter the sitters by revealing the property that bespoke their social status.[26] Wyeth's objectives are more aesthetic and much less concerned with the land as an emblem of status. In some instances, Wyeth is displaying his mastery of *trompe-l'oeil* techniques, or his interest in interior-exterior relationships; but above all, I believe, he is engaged by the resonance and the dissonance in our minds when we glimpse the natural world through the portals and refractions of our built environment. Our constructive mastery is mitigated by nostalgia for a pristine past.

Wyeth delights in looking at landscape from two other, diametrically opposed perspectives. The first I call the snail's-eye view—the terrain seen from below, in which the landscape is often limitless and unconstrained. Examples become increasingly dramatic during the course of his career: SPRING LANDSCAPE AT KUERNERS (1933); WINTER, 1946 (Fig. 58); CHRISTINA'S WORLD (Figs. 1, 61); BROWN SWISS (Fig. 82); and FROZEN POND (1968).

167. Ralph Earl
PORTRAIT OF OLIVER ELLSWORTH
AND ABIGAIL WOLCOTT ELLSWORTH, 1792
Oil on canvas, 75¹⁵⁄₁₆ x 86¾ (192.9 x 220.3)
Wadsworth Atheneum, Hartford; Gift of the Ellsworth Heirs

The second perspective could be called the bird's-eye view, except that in the most famous instance, SOARING (1950; Fig. 60), the artist's vantage is actually above the birds! God's-eye view might be a better term. I also have in mind PENNSYLVANIA LANDSCAPE (1942; Fig. 69), of which Wyeth said, "I'm almost suspended, looking down....I never stand in one spot....I float. I move." Other such works are NORTHERN POINT (1950), END OF OLSONS (1969; Fig. 128), LAMPLIGHT (1975), and EASTER SUNDAY (1975).[27]

When viewers are situated at the bottom of a big hill, they feel almost overwhelmed by it, and find it hard to adjust to the heavenward perspective. But to "overlook" the terrain from above, whether it is familiar or not, as though from a helicopter, is literally as well as figuratively sensational because the perspective is superhuman. Either way the terrain is elusive because the viewer cannot encompass it in its entirety. We can only imagine its extent, and where it might lead.

On occasion Wyeth also paints landscapes in which we are approximately at eye level with the terrain. These may be very beautiful, such as LIME BANKS (1962; Fig. 96) and FLOUR MILL (1985), but their mysteries and their mastery lie elsewhere because their perspective presents us with fewer problems. Less often, Wyeth positions us so that we are located on the high ground looking way down to a narrow valley from which rolling hills rise up and away once again—what I call the roller-coaster perspective (see BATTLEGROUND, 1981; Fig. 168), one that can command our gaze for a considerable period of time because there is so much to scan and internalize. BATTLEGROUND is a *tour de force* of portraiture, architecture, landscape, and even Wyeth's love of local history. Here are some of his comments on this compelling picture:

This is precisely where Henry Knox fought at the Battle of Brandywine. I've always been interested in tire tracks with snow lying on them—they look like some sort of hieroglyphics. It's deep winter, freeze time. I love snow; I love Pennsylvania in the winter. It's not pretty. New England is. The Brandywine's sort of ugly, looking like what George Washington must have felt when he camped at Valley Forge. Tough living. I like the difference between New England and this tough place.[28]

Andrew Wyeth does not like having his art categorized. Within the broad rubric of realism, he is a man of varied techniques, tricks, and artistic trysts. He is a maverick who characteristically proclaims, "What you have to do is break all the rules."[29] That he does, successfully creating both resonance and dissonance, a great deal of both, in fact. As for inspiration—why he paints what he paints, and when—he invariably insists: "I have to feel the hair raised on my neck." Ultimately, then, the icon is an iconoclast, which may help to explain why Wyeth's seemingly familiar terrain so often remains enigmatic.

168. BATTLEGROUND, 1981
Tempera on panel, 49⅝ x 45⅝ (126 x 115.9)
The Nelson Atkins Museum of Art, Kansas City, Missouri

Endnotes

1. Quoted in E.P. Richardson, "Andrew Wyeth," *The Atlantic*, 213 (June 1964), p. 64.

2. See Richard Meryman, *Andrew Wyeth: A Secret Life* (New York: Harper Collins Publishers, 1996), pp. 23, 227-28.

3. Quoted in Brian O'Doherty, "A Visit to Wyeth Country," in Wanda M. Corn, *The Art of Andrew Wyeth*, exh. cat. (San Francisco: The Fine Arts Museums of San Francisco, 1973), p. 38. For a somewhat different description of the process that started *Christina's World*, see George Plimpton and Donald Stewart, "Andrew Wyeth," *Horizon*, 4 (September 1961), p. 98.

4. Quoted by J.G. Wirt in the *Sacramento Bee*, July 12, 1997, p. A2.

5. For reproductions of the works referred to in this paragraph, see Andrew Wyeth, *Autobiography*, introd. by Thomas Hoving (Boston: Little, Brown and Company, 1995), pp. 45-46, 64, 78, 113, 129.

6. Ibid., p. 68; Meryman, *Andrew Wyeth*, p. 403.

7. Ibid., p. 407.

8. O'Doherty, "A Visit to Wyeth Country," p. 24.

9. N.C. Wyeth to Andrew Wyeth, February 16, 1944, in Betsy James Wyeth, ed., *The Wyeths: The Letters of N.C. Wyeth, 1901-1945* (Boston: Gambit, 1971), pp. 833, 835; italics in the original.

10. Wyeth, *Autobiography*, pp. 11, 39.

11. Ibid., p. 149; Meryman, *Andrew Wyeth*, pp. 124, 257-58.

12. Quoted in Meryman, *Andrew Wyeth*, p. 97.

13. Andrew Brighton, "Clement Greenberg, Andrew Wyeth, and Serious Art," in *Views from Abroad: European Perspectives on American Art 3. American Realities*, exh. cat. (New York: Whitney Museum of American Art, 1997), p. 102. That statement was echoed in the *Portland* [Maine] *Press Herald* on August 3, 1997, p. 3E: "an artist who is beyond doubt the most popular serious artist in America."

14. Richard Meryman, "Andrew Wyeth: An Interview," *Life*, May 14, 1965, reprinted in Corn, *The Art of Andrew Wyeth*, p. 76; "World News Tonight with Peter Jennings," July 18, 1997, "Person of the Week" interview. There is more than a touch of irony in the Wyeth family exhibition in Leningrad and Moscow in March-May 1987, several years before the collapse of the Soviet Union—an exhibition venue suggested by Wyeth himself after the 1985 Reagan-Gorbachev summit, which included an agreement to foster cultural exchanges between the two superpowers. The Soviets barred the inclusion of James Wyeth's 1977 study of the émigré dancer Rudolf Nureyev!

15. "American Realist," *Time*, July 16, 1951, pp. 72, 75; *Andrew Wyeth: Temperas, Watercolors, Dry Brush, Drawings, 1938 into 1966*, exh. cat. (Philadelphia: Pennsylvania Academy of the Fine Arts, 1966), pp. 32-33. For an astute commentary on youth as a metaphor for America, see C. Vann Woodward, *The Old World's New World* (New York: Oxford University Press, 1991), pp. vii-viii, 65-70.

16. Woodward, *The Old World's New World*, p. 68. See also Wyeth's figurative landscape, *The Swinger* (1969), ibid., p. 82.

17. For the Wyeth ancestry, see Meryman, *Andrew Wyeth*, pp. 244, 254; Katherine Kuh discusses Wyeth's conservative politics in "Why Wyeth?" in Kuh, *The Open Eye, In Pursuit of Art* (New York: Harper & Row, 1971), p. 17; Wyeth's remarks on *The Liberal* appear in Wyeth, *Autobiography*, p. 147.

18. Yi-Fu Tuan, "Geopiety: A Theme in Man's Attachment to Nature and to Place," in David Lowenthal and Martyn J. Bowden, eds., *Geographies of the Mind: Essays in Historical Geosophy in Honor of John Kirtland Wright* (New York: Oxford University Press, 1976), pp. 11-39; p. 35 for the passage quoted.

19. For Wyeth's initial problems in adjusting to Maine, see Meryman, *Andrew Wyeth*, pp. 402, 133; *Pittsburgh Post-Gazette*, September 27, 1997; *The Sunday Times* [London], June 15, 1997. Meryman, "Andrew Wyeth," p. 74: "I couldn't get any of this feeling without a very strong connection for a place."

20. Wyeth, *Autobiography*, pp. 31, 56, 118, 122. See also *Sailor's Valentine* (1985), *Pentecost* (1989), and *Battleground* (1981; Fig. 168), ibid., pp. 128, 142, 153; and for "my valley," ibid., p. 24.

21. Interview by George Howe Colt, *Life*, March 1997, p. 74.

22. Wyeth to his parents, May 16 and 17, 1938, The Andrew Wyeth Collection, Chadds Ford, Pennsylvania.

23. Beth H. Stickney (Port Washington, New York) to the Editor, *The New York Times*, September 6, 1986, p. 26.

24. See O'Doherty, "A Visit to Wyeth Country," p. 40; Meryman, *Andrew Wyeth*, pp. 88-89.

25. For reproductions of the works cited in this paragraph see *Two Worlds of Andrew Wyeth: Kuerners and Olsons*, exh. cat. (New York: The Metropolitan Museum of Art, 1976), pp. 144-45, 159; Wyeth, *Autobiography*, pp. 118-19, 129.

26. See, for example, Elizabeth Mankin Kornhauser et al., *Ralph Earl: The Face of the Young Republic*, exh. cat. (New Haven: Yale University Art Gallery, 1992), pp. 7, 50, 85, 148, 162, 164, 181-82, 185, 190-91, 195-96, 204, 209, 212, 214-15, 224-25, 233, 244.

27. For the passage quoted, see Wyeth, *Autobiography*, p. 20. These techniques of perspective from high above and low down enjoyed particular appeal in the United States during the 1930s; see Corn, *The Art of Andrew Wyeth*, pp. 108-09, 144.

28. Wyeth, *Autobiography*, pp. 8 and 153. Compare the epigraph at the beginning of this essay.

29. Ralph Blumenthal, "Still Sovereign of His Own Art World," *The New York Times*, February 18, 1997, p. C11.

UNTITLED (Study for BROWN SWISS), 1957
(Fig. 81)
Watercolor on paper, 10¾ x 13½ (27.3 x 34.3)
Collection of Andrew and Betsy Wyeth

UNTITLED (Study for BROWN SWISS), 1957
(Fig. 83)
Watercolor on paper, 21⅝ x 29¾ (54.9 x 75.6)
Collection of Andrew and Betsy Wyeth

UNTITLED (Study for BROWN SWISS), 1957
(Fig. 98)
Watercolor on paper, 10⅞ x 13⅜ (27.6 x 34)
Collection of Andrew and Betsy Wyeth

UNTITLED (Study for BROWN SWISS), 1957
(Fig. 99)
Watercolor on paper, 10⅞ x 13⅜ (27.6 x 34)
Collection of Andrew and Betsy Wyeth

FLOATING LEAVES, 1958 (Fig. 90)
Watercolor on paper, 13½ x 21 (34.3 x 53.3)
Collection of Andrew and Betsy Wyeth

RIVER COVE, 1958 (Fig. 91)
Tempera on masonite, 48 x 30¼ (121.9 x 76.8)
Private collection

RIVER PINE, 1958 (Fig. 93)
Watercolor on paper, 20 x 28½ (50.8 x 72.4)
Collection of Jane W. Smith

UNTITLED (RIVER COVE STUDY), 1958
(Fig. 86)
Watercolor on paper, 14⅜ x 23⅛ (36.5 x 58.7)
Collection of Andrew and Betsy Wyeth

FIRST SNOW (GROUNDHOG DAY STUDY),
1959 (Fig. 117)
Drybrush on paper, 13⅜ x 21¼ (33.9 x 54)
Delaware Art Museum, Wilmington; Gift of
Mr. and Mrs. William E. Phelps

WINTER BEES, 1959 (Fig. 89)
Drybrush on paper, 21 x 27 (53.3 x 68.6)
Collection of Andrew and Betsy Wyeth

ABOVE THE NARROWS, 1960 (Fig. 95)
Tempera on panel, 48 x 32¼ (121.9 x 81.9)
Private collection

THE DAM, 1960 (Fig. 107)
Watercolor on paper, 10⅜ x 14⅜ (26.4 x 36.5)
Collection of Andrew and Betsy Wyeth

DISTANT THUNDER STUDY, 1961 (Fig. 101)
Watercolor on paper, 11½ x 22¼ (29.2 x 56.5)
Collection of Andrew and Betsy Wyeth

THE GRANARY, 1961 (Fig. 105)
Watercolor on paper, 13⅜ x 21⅝ (34.6 x 54.9)
Collection of Andrew and Betsy Wyeth

TENANT FARMER, 1961 (Fig. 103)
Tempera on panel, 30½ x 40 (77.5 x 101.6)
Delaware Art Museum, Wilmington; Gift of
Mr. and Mrs. William E. Phelps

UNTITLED, 1961 (Fig. 94)
Watercolor on paper, 21½ x 29¾ (54.6 x 75.6)
Collection of Andrew and Betsy Wyeth

UNTITLED (DISTANT THUNDER STUDY),
1961 (Fig. 102)
Watercolor on paper, 15⅞ x 11⅞ (40.3 x 30.2)
Collection of Andrew and Betsy Wyeth

UNTITLED (DISTANT THUNDER STUDY),
1961 (Fig. 111)
Watercolor on paper, 23⅛ x 17⅝ (58.7 x 44.8)
Collection of Andrew and Betsy Wyeth

UNTITLED (TENANT FARMER STUDY), 1961
Watercolor on paper, 20 x 14 (50.8 x 35.6)
Collection of Andrew and Betsy Wyeth

UNTITLED (TENANT FARMER STUDY), 1961
(Fig. 100)
Watercolor on paper, 14¾ x 13¾ (37.5 x 34.9)
Collection of Andrew and Betsy Wyeth

LIME BANKS, 1962 (Fig. 96)
Tempera on panel, 26¾ x 51½ (67.9 x 130.8)
Private collection

LIME BANKS STUDY, 1962 (Fig. 97)
Watercolor on paper, 19½ x 39 (49.5 x 99)
Collection of Andrew and Betsy Wyeth

UNTITLED, 1962 (Fig. 108)
Watercolor on paper, 21¼ x 29¾ (54 x 75.6)
Collection of Andrew and Betsy Wyeth

UNTITLED, 1962 (Fig. 122)
Watercolor on paper, 30 x 21 (76.2 x 53.3)
Collection of Andrew and Betsy Wyeth

CAROLYN WYETH, 1963 (Fig. 110)
Watercolor and graphite on paper, 20¾ x 29¾
(52.7 x 75.6)
Collection of Andrew and Betsy Wyeth

CIDER APPLES, 1963 (Fig. 109)
Watercolor on paper, 18½ x 23½ (47 x 59.7)
Collection of Andrew and Betsy Wyeth

UNTITLED, 1963 (Fig. 112)
Watercolor on paper, 22 x 30½ (55.9 x 77.5)
Collection of Andrew and Betsy Wyeth

PULP WOOD, 1964 (Fig. 123)
Drybrush and watercolor on paper, 20 x 39⅞
(50.8 x 101.3)
Collection of Andrew and Betsy Wyeth

UNTITLED (WOODCHOPPER STUDY), 1964
(Fig. 149)
Watercolor on paper, 14 x 20 (35.6 x 50.8)
Collection of Andrew and Betsy Wyeth

FAR FROM NEEDHAM, 1966 (Fig. 121)
Tempera on panel, 44 x 41 (111.8 x 104.1)
Private collection

RIVER VALLEY, 1966 (Fig. 120)
Watercolor on paper, 21¾ x 30 (55.2 x 76.2)
Collection of Andrew and Betsy Wyeth

UNTITLED, 1966 (Fig. 114)
Watercolor on paper, 19 x 28 (48.3 x 71.1)
Collection of Andrew and Betsy Wyeth

UNTITLED (ARMY SURPLUS STUDY), 1966
(Fig. 104)
Watercolor on paper, 19 x 28 (48.3 x 71.1)
Collection of Andrew and Betsy Wyeth

THE SWEEP, 1967 (Fig. 125)
Tempera on masonite, 23⅞ x 34¹³⁄₁₆ (60.6 x 88.4)
Flint Institute of Arts, Michigan; Gift of the
Viola E. Bray Charitable Trust

END OF OLSONS, 1969 (Fig. 128)
Tempera on panel, 18¼ x 19 (46.4 x 48.3)
Private collection

ICE POOL, 1969 (Fig. 119)
Watercolor on paper, 21½ x 29 (54.6 x 73.7)
Private collection

SPRUCE BOUGH, 1969 (Fig. 118)
Watercolor on paper, 21¼ x 29⅜ (54 x 74.6)
Private collection

UNTITLED, 1969 (Fig. 127)
Watercolor on paper, 28 x 20 (71.1 x 50.8)
Collection of Andrew and Betsy Wyeth

COUNTRY WEDDING, 1970 (Fig. 124)
Watercolor on paper, 22 x 29 (55.9 x 73.7)
Herbert F. Johnson Museum of Art, Cornell
University, Ithaca, New York

EVENING AT KUERNERS, 1970 (Fig. 131)
Drybrush and watercolor on paper, 25½ x 29¾
(64.8 x 75.6)
Collection of Andrew and Betsy Wyeth

LAAKA FARM, 1970 (Fig. 130)
Watercolor on paper, 19 x 28⅜ (48.3 x 72)
Collection of Andrew and Betsy Wyeth

SPRUCE GROVE, 1970 (Fig. 129)
Watercolor on paper, 18½ x 27½ (47 x 69.9)
Collection of Mr. and Mrs. Walter J. Winther

DOWN HILL, 1971 (Fig. 133)
Watercolor on paper, 26¾ x 38 (67.9 x 96.5)
Collection of Andrew and Betsy Wyeth

EASTMAN'S BROOK, 1971 (Fig. 135)
Watercolor on paper, 22¾ x 29¾ (57.8 x 75.6)
Collection of Andrew and Betsy Wyeth

WINTER MONHEGAN, 1971 (Fig. 132)
Watercolor on paper, 21 x 29 (53.3 x 73.7)
Collection of Andrew and Betsy Wyeth

UNTITLED, 1974 (Fig. 136)
Watercolor on paper, 18¾ x 23½ (47.6 x 59.7)
Collection of Andrew and Betsy Wyeth

UNTITLED (Study for EASTER SUNDAY), 1975
(Fig. 141)
Watercolor on paper, 27 x 40 (68.6 x 101.6)
Collection of Andrew and Betsy Wyeth

UNTITLED, 1978 (Fig. 134)
Watercolor on paper, 21⅝ x 29¾ (54.9 x 75.6)
Collection of Andrew and Betsy Wyeth

UNTITLED, 1978 (Fig. 137)
Watercolor on paper, 29⅞ x 21⅞ (75.9 x 55.6)
Collection of Andrew and Betsy Wyeth

UNTITLED, 1978 (Fig. 140)
Watercolor on paper, 21¾ x 30 (55.2 x 76.2)
Collection of Andrew and Betsy Wyeth

MAPLE LEAVES, 1979 (Fig. 126)
Watercolor on paper, 14 x 20 (35.6 x 50.8)
Collection of Andrew and Betsy Wyeth

UNTITLED, 1979 (Fig. 138)
Watercolor on paper, 22 x 29⅞ (55.9 x 75.9)
Collection of Andrew and Betsy Wyeth

UNTITLED, 1980 (Fig. 142)
Watercolor on paper, 21⅜ x 30 (54.3 x 76.2)
Collection of Andrew and Betsy Wyeth

BUTTONWOOD LEAF, 1981 (Fig. 143)
Drybrush on paper, 13 x 16½ (33 x 41.9)
Collection of Andrew and Betsy Wyeth

CORNER OAK, 1981 (Fig. 152)
Watercolor on paper, 21 x 29 (53.3 x 73.7)
Private collection

OLIVER'S CAP, 1981 (Fig. 154)
Tempera on panel, 48 x 47½ (121.9 x 120.7)
Collection of Ronald and Diane Miller

BACKWATER (STUDY), 1982 (Fig. 139)
Watercolor on paper, 10 x 14 (25.4 x 35.6)
Collection of Andrew and Betsy Wyeth

Study for TREE HOUSE, 1982
Watercolor on paper, 18¾ x 30 (47.6 x 76.2)
Collection of Andrew and Betsy Wyeth

Study for TREE HOUSE, 1982
Graphite on paper, 12 x 17¾ (30.5 x 45.1)
Collection of Andrew and Betsy Wyeth

Study for TREE HOUSE, 1982
Graphite on paper, 12 x 17¾ (30.5 x 45.1)
Collection of Andrew and Betsy Wyeth

As of February 17, 1998

LENDERS

Dr. and Mrs. Ronald Brady

Brandywine River Museum, Chadds Ford, Pennsylvania

Colby College Museum of Art, Waterville, Maine

Delaware Art Museum, Wilmington

Everson Museum of Art of Syracuse and Onandaga County, Syracuse, New York

Flint Institute of Arts, Flint, Michigan

Herbert F. Johnson Museum of Art, Cornell University, Ithaca, New York

Lyman Allyn Art Museum, New London, Connecticut

Mead Art Museum, Amherst, Massachusetts

Ronald and Diane Miller

Mint Museum of Art, Charlotte, North Carolina

The Museum of Modern Art, New York

National Gallery of Art, Washington, D.C.

Mr. and Mrs. Charles Noble

North Carolina Museum of Art, Raleigh

Portland Museum of Art, Maine

Robert L.B. Tobin

Shelburne Museum, Shelburne, Vermont

Jane W. Smith

Whitney Museum of American Art, New York

Mr. and Mrs. Walter J. Winther

Andrew and Betsy Wyeth

Eighteen private collections

WHITNEY MUSEUM
OF AMERICAN ART
OFFICERS AND TRUSTEES

Leonard A. Lauder, *Chairman*

Gilbert C. Maurer, *President*

Nancy Brown Wellin, *Vice Chairman*

Robert W. Wilson, *Vice Chairman*

Joanne Leonhardt Cassullo, *Vice President*

Sondra Gilman Gonzalez-Falla,
 Vice President

Emily Fisher Landau, *Vice President*

Thomas H. Lee, *Vice President*

Adriana Mnuchin, *Vice President*

Peter Norton, *Vice President*

Joel S. Ehrenkranz, *Treasurer*

David A. Ross, *Director*

Steven Ames

Michele Beyer

Flora Miller Biddle, *Honorary Chairman*

Murray H. Bring

Melva Bucksbaum

Joan Hardy Clark

Beth Rudin DeWoody

Joseph C. Farina

Arthur Fleischer, Jr.

Henry Louis Gates, Jr.

Philip H. Geier, Jr.

Ulrich Hartmann

Robert J. Hurst

George S. Kaufman

Henry Kaufman

Raymond J. Learsy

Douglas B. Leeds

John A. Levin

Faith Linden

Raymond J. McGuire

Diane Moss

Brian O'Doherty

Allen Questrom

Fran W. Rosenfeld

Stephen A. Schwarzman

Henry R. Silverman

Norah Sharpe Stone

Laurie Tisch Sussman

B.H. Friedman, *Honorary Trustee*

Susan Morse Hilles, *Honorary Trustee*

Michael H. Irving, *Honorary Trustee*

Roy R. Neuberger, *Honorary Trustee*

Thomas N. Armstrong III,
 Director Emeritus

Marilou Aquino, *Secretary*

222

WHITNEY MUSEUM
 OF AMERICAN ART
EXHIBITION ASSOCIATES

Ruth Bowman

Melva Bucksbaum

Jeffrey Deitch

Carol and Maurice Feinberg

Barbara S. Horowitz

Harry Kahn

Estelle Konheim

Nanette Laitman

Evelyn and Leonard A. Lauder

Jane Lombard

Susan and Edwin Malloy

Ann and Gilbert Maurer

Adriana and Robert Mnuchin

Eliot and Wilson Nolen

Helen and David B. Pall

Louisa Stude Sarofim

Ruth and Herbert Schimmel

Joan and Jerome Serchuck

Manon and Ian Slome

Sally and Herbert E. Solomon

Sue Erpf Van de Bovenkamp

Rebecca Cooper Waldman and Michael Waldman

Geoffrey Webster

Nancy and Keith Wellin

Phyllis and Jack Wertenteil

Thea Westreich and Ethan Wagner

Michael Kammen is the Newton C. Farr Professor of American History and Culture at Cornell University in Ithaca, New York. He won the Pulitzer Prize for History in 1973, and has written and lectured widely about American history and culture. Kammen's recent books include *In the Past Lane: Historical Perspectives on American Culture*, and *The Lively Arts: Gilbert Seldes and the Transformation of Cultural Criticism in the United States*.

This publication was organized at the Whitney Museum
by Mary E. DelMonico, Head, Publications; Sheila Schwartz, Editor;
Nerissa C. Dominguez, Production Manager; Dale Tucker, Copy Editor;
and Christina Grillo, Assistant.

Design: Lorraine Wild with Amanda Washburn
Printing and Binding: Dr. Cantz'sche Druckerei, Ostfildern
Printed and bound in Germany

Library of Congress Cataloging-in-Publication Data
Venn, Beth.
Unknown terrain: the landscapes of Andrew Wyeth/Beth Venn
and Adam D. Weinberg; with a contribution by Michael
Kammen.
p. cm.
Catalog of an exhibition at the Whitney Museum of American
Art, May 28–Aug. 30, 1998.
ISBN 0-87427-116-9 (Whitney pbk. ed.: acid-free paper). —
ISBN 0-8109-6827-4 (Harry N. Abrams cloth ed.: acid-free
paper)
1. Wyeth, Andrew, 1917- —Exhibitions. 2. Landscape in
art—Exhibitions. I. Wyeth, Andrew, 1917- . II. Weinberg,
Adam D. III. Kammen, Michael. IV. Whitney Museum of
American Art. V. Title. ND1837.W94A4 1998
759.13—dc21 98-10230
 CIP

ISBN 0-87427-116-9 (Whitney Museum of American Art: paper)
ISBN 0-8109-6827-4 (Harry N. Abrams, Inc.: cloth)

© 1998 Whitney Museum of American Art
945 Madison Avenue, New York, New York 10021

All rights reserved. No part of this publication may be repro-
duced in any form or by any means, electronic, photocopy,
information retrieval system, or otherwise without written
permission from the Whitney Museum of American Art.

Photograph and Reproduction Credits
Ken Burris: 77; Robert Carafelli: 22, 93; Sheldan C. Collins:
82; Robert Crowe: 95; Erich Lessing/Art Resource, NY:
28 (center); Bernard C. Meyers: 71; © 1998 The Museum
of Modern Art, New York: 20 (left), 78; Joseph Painter:
94, 118; Peter Ralston: 205; Billy Ray, III: 149; Jim Strong,
Inc.: 117; Hugh Tifft: 76.

All images by Andrew Wyeth © 1998 Andrew Wyeth